MIXED MEDIA LANDSCAPES AND SEASCAPES

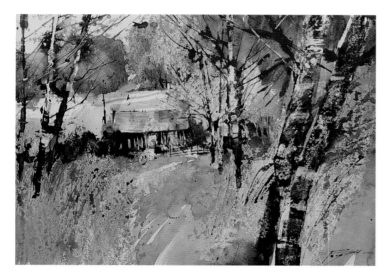
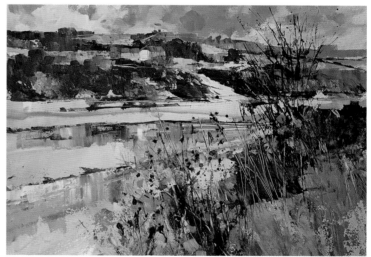

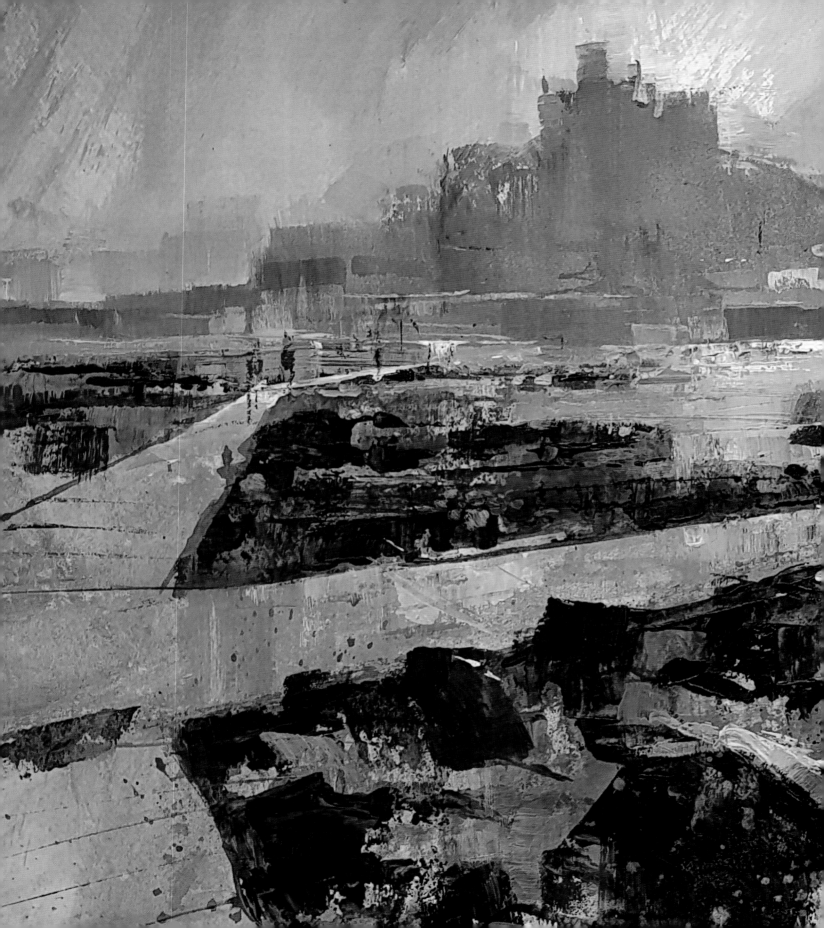

MIXED MEDIA
LANDSCAPES AND SEASCAPES

Christopher Forsey

BATSFORD

My sincere thanks to Deanna Sergent for her support in planning the book and
both my daughters, Charlotte for her work on the book and especially Olivia for her
patience and valued help in organising me and preparing the book content.

First published in the United Kingdom in 2020 by

Batsford

43 Great Ormond Street

London

WC1N 3HZ

An imprint of Pavilion Books Company Ltd

ISBN 978-1-84994-535-6

A CIP catalogue record for this book is available from the British Library.

10 9 8 7 6 5 4 3 2 1

Reproduction by Rival Colour Ltd, UK

Printed and bound by Toppan Leefung Printing Ltd, China

This book can be ordered direct from the publisher at www.pavilionbooks.com

FSC
www.fsc.org

MIX
Paper from
responsible sources
FSC® C104723

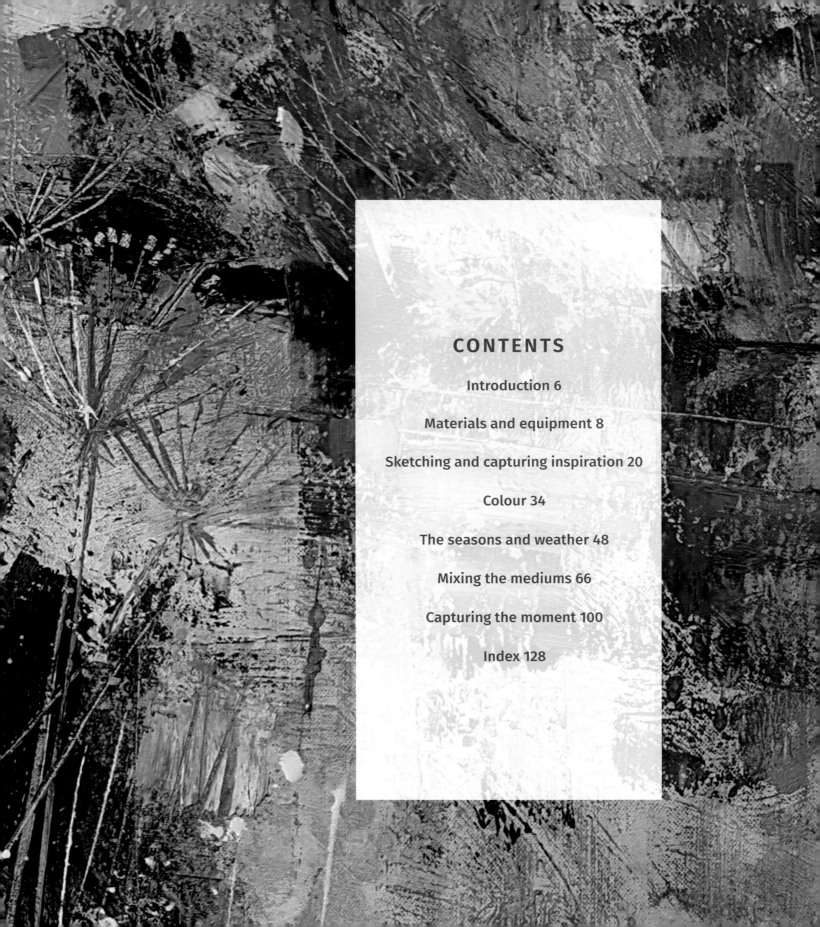

CONTENTS

INTRODUCTION

Our world presents artists with never-ending opportunities for inspiration, interpretation and the representation of these ideas in our paintings. Even the smallest patch of landscape can give each of us the chance to explore individual creative ideas and allow true personal expression to follow. The medium we use plays a large part in the appearance of the finished work – the liquidity of inks, the transparency of watercolours, the opacity and texture of pastels and the expressive marks and brushstrokes of acrylic. All of these can be combined in different ways to create a truly individual result, full of expression, energy and excitement. I hope that this book will inspire you and take you on a rewarding creative journey.

The aims of this book

The choice available to artists these days regarding materials, tools and styles can be overwhelming. A visit to any art shop, whether on the high street or online, can leave a novice artist somewhat confused as to which mediums to choose and how to use them creatively. My aim is to give you an introduction to the materials you might wish to try and show how you might combine them to get the most from a mixed-media adventure in paint. My suggestions and advice are just a guide; it's only through exploring and experimenting that you will find your true personal direction.

 In this book you'll find examples of painting using just two mediums, progressing to those using four or five to create a mixed-media combination that uses texture, mark-making, transparency, opacity, spontaneity and expression. There's real visual excitement in the end result, and this way of painting is lots of fun, too. I hope this book will spark your creativity and open new horizons in how you see your art.

The Little Harbour, Boat Boxes, Cottages
40½ × 51cm (16 × 20in)
*Acrylic, paint, acrylic ink
and oil pastel on acrylic paper*

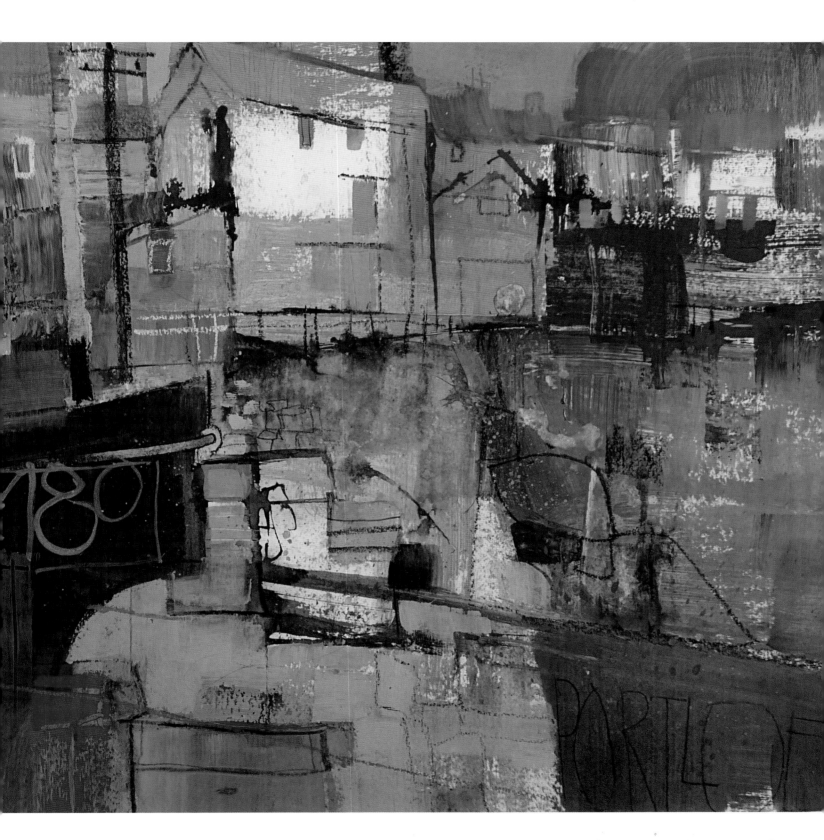

MATERIALS AND EQUIPMENT

The well-known painting mediums come in many colours and with methods of application that include brush, knife, scraper, roller and pen. Using combinations of them can add more complexity and interest to the appearance of an artwork. Some of these combinations are apparent in the work of such artists as John Piper (1903–92). Post-war austerity and no doubt a shortage of art supplies encouraged his use of available materials such as Indian ink, wax crayons, watercolour and gouache, which give his work on paper a certain appearance and quality we admire today. Earlier, Edgar Degas (1834–1917) used soft pastel over watercolour to great effect. We can learn a lot about combining different materials by looking at the work of these two artists and in particular at how one medium affects another; sometimes their non-compatibility produces just the effect we want in order to create exciting surfaces and dynamism in our paintings. A willingness to spend plenty of time on trial and error is very important in the mastering of how to get the most from your materials, combining them to give stimulating results.

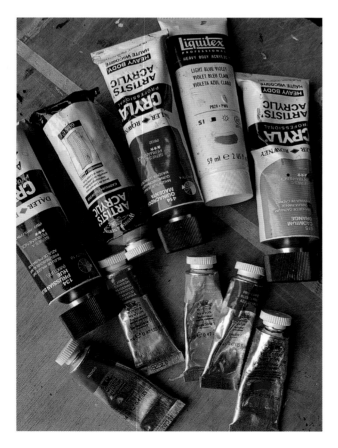

Painting materials

I began my fine art career as a watercolourist, never looking elsewhere for a means of creating a painting. However, as an illustrator I had had extensive experience of using gouache and gradually I started to add it to my watercolour paintings. This made me want to explore further and a cornucopia of exciting products was revealed to me. I tried nearly all of them. Some I liked a lot, others I didn't respond to so much, but they all offered possibilities for experimentation. Here's a list of my choice of materials.

LEFT Acrylic and watercolour paints.
OPPOSITE Acrylic ink, wax crayons and oil pastels.

WATERCOLOURS

I use artist-quality watercolours in tubes. The colours are richer, juicier and more intense in colour than the student-quality tubes and watercolours in pans, and react in a more interesting way with water and other mediums, promoting spontaneous expression and unpredictable results. When squeezed directly from the tube the paint can be applied in a dry, rich way, sometimes emulating oil or acrylic, and is useful combined with the thinner transparent washes. Watercolour in bottles can be useful too, dense in hue and exciting to work with.

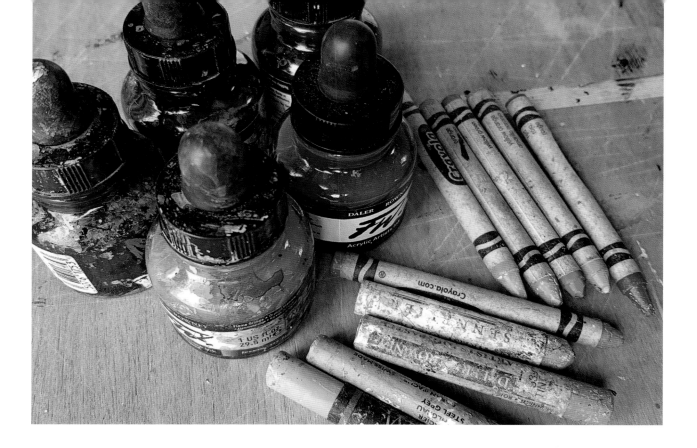

ACRYLIC INKS

I often use acrylic inks from bottles that have a pipette in the cap. The pipette is handy for squeezing ink into a palette, though I regularly use it for drawing directly onto the painting. My colours of choice are surprisingly small from a large range. I use the darker colours: browns including Sepia, Antelope Brown and Burnt Umber, together with Payne's Grey, Indigo and Purple Lake. In addition, orange and white inks can be very useful, the white being highly opaque.

ACRYLIC PAINT

This is a very versatile medium, which can be mixed with plenty of water to emulate pure watercolour, or layered thickly onto the support like oil paints. I use it both in its transparent state, mixed with water or a lot of acrylic medium, and in its opaque, undiluted form.

OIL PASTELS

I like oil pastels for both starting a painting and adding finishing touches of colour. They make a good resist to watercolours and very diluted inks and their opacity makes them useful for scumbling over a layer of painted pigment.

WAX CRAYONS

I carry these with me whenever I go sketching, either for adding a dash of colour to a monochrome sketch or for making a resist to a watercolour wash.

WATER-SOLUBLE CRAYONS

When you're sketching you can add water to a scribble of colour made with these crayons, and create a useful colour wash that you can draw into again while it's still wet, to create a broken, blurry line. I particularly enjoy using a dark crayon as it adds texture and tone to the sketch drawing. The crayons are also useful for a dynamic element of drawing added to the painting in the later stages.

Tools

While a lot of tempting equipment is to be found in art shops and online catalogues, you won't need most of it. It's best to buy a limited range and get to know it well, then you can make educated decisions about any extras you may want to try.

BRUSHES

Finding the right brush can take a lot of trial and error before you hit upon the shape and size that suits you best. I prefer a flat brush as it can be laid on its face and dragged across the support, thus creating a flat, broad mark, or the sharp tip can be applied to make a linear mark. Combining both methods gives the artist a lot of alternatives in mark-making. I use a surprisingly small selection: 50mm (2in), 38mm (1½in) and 25mm (1in). I also use a rigger occasionally for its long, fine hairs.

The water brush, or water pen as it is sometimes called, is a useful addition to the artist's arsenal of sketching equipment. It is a brush that houses water in the barrel of its handle. The water is supplied to the brush end via a valve, giving a supply of water when the handle is gently squeezed, allowing the artist to sketch with colour using just paints and the brush, no water pot needed. It can be refilled from any tap or water supply by unscrewing the reservoir or immersing the water brush in water and squeezing the barrel.

PALETTE KNIFE

These knives come in a range of shapes and sizes. I use them to add sharp-edged marks, broad, sweeping gestural marks and smears and also for detailed linear additions.

CARD, PLASTIC AND TISSUE PAPER

Pieces of card in various shapes and sizes are useful for drawing and mark-making. The edge of a plastic card can be handy for pressing marks onto the paper, and so can scrunched-up cellophane. By applying pigment, paint or ink to these materials and just using hand pressure, a variety of random and unpredictable marks can be printed onto the painting surface to create lines and textures.

Kitchen towel or paper tissue can be used for the removal of paint to reveal an earlier surface of colour. This can sometimes be better than using an already grubby rag that could apply colour by mistake.

ROLLERS

I like both hard and sponge rollers for creating random, broad tracks of textural paint.

MASKING FLUID

Masking fluid can be useful for protecting areas of the painting that you wish to retain as white when broad washes of colour are used.

GRAPHITE PENCILS

Graphite pencils, crayons or blocks can be very handy for sketching. The block or crayon can be used on its edge to create broad, tonal marks, the softer-graphite 4B or 6B giving a darker, tonal shade. A lighter mark can be lifted from this area of tone by using the edge of a soft eraser.

ABOVE Marks made using a palette knife.

RIGHT A selection of tools used in my work.

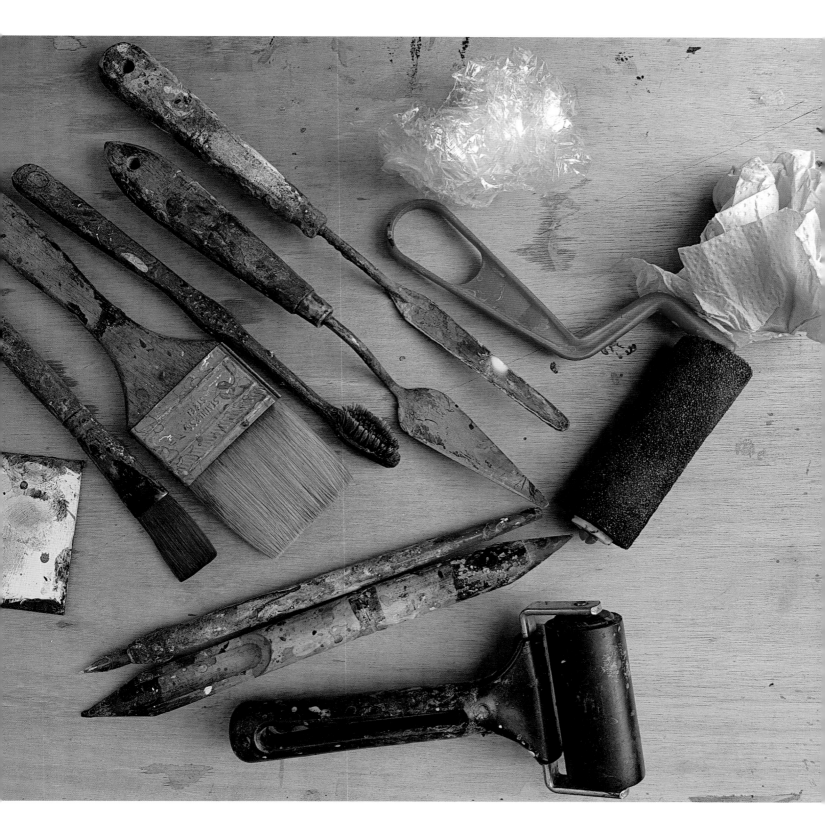

Painting surfaces

There are numerous painting surfaces available to you and with experience you will come to know which you favour. Most manufacturers produce watercolour paper in three different surfaces – Cold Press (also known as Not), Hot Press (HP) and Rough. It is worth trying each of these to discover which one will suit your needs for a particular painting. HP paper allows the paint to dry quickly but its smooth surface does not encourage some of the textures and effects that Rough and Not paper can produce. However, I find that Rough papers are sometimes too textured

and the mark-making in pastel and acrylic can be a little crude. For watercolour-based work I choose Not and Rough papers, but where acrylics are concerned a smoother surface allows the paints to move in a way that reflects the movement of the brushstrokes without breaking up on the surface as they will with Not and Rough paper. Some manufacturers produce paper for acrylics, but this is not good for watercolour. However, acrylics can work well on watercolour paper, especially HP or Not-finish papers.

ABOVE Marks made on smooth watercolour paper.

RIGHT Marks made on rough watercolour paper.

Mark-making

The various tools and mark-makers I employ produce a wide variety of paint smears, lines, dots, printed textures and so forth. Nearly everything can provide a mark on a surface, from the accidental to the planned, and it is this aspect of painting in mixed media that is so exciting. The most straightforward of marks, for example a line, can prove more interesting if you are using apparently the wrong tool for the job. You might find yourself surprised and inspired by some of the results that occur through embracing experimentation with various tools and mediums.

Linear mark-making

Pens For the sort of line shown here I often use a bamboo pen. This traditional tool can give a calligraphic result if used heavily laden with ink or watercolour. It is unpredictable – it may produce blots and the pen may run out of ink at the wrong moment – but this can add to the painterly quality of the result. In the example here I have also spattered water into the mark to create interesting results. A steel-nibbed pen is also very useful for finer drawing as more precision can be expected.

Toothbrush This is an underrated piece of art equipment, obviously intended for a different use, but the results can be surprisingly useful and expressive; its broadly spaced bristles can create marvellous linear marks simulating grass and seedheads. Here a brush loaded with acrylic ink has been pulled, pushed and scrubbed across the paper, leaving clusters of fine, linear marks indicating a grassy, uncut nature. I have also spattered more ink on top by dragging my forefinger across the toothbrush's bristles – this is a great effect for many surfaces, such as sand, shingle, concrete, plaster and so on. A finer result can be achieved by carrying out the spattering process nearer to the painting surface.

ABOVE Marks made with a bamboo pen.
RIGHT Marks made with a toothbrush.

Broad marks

Brushes A wide 50mm (2in) flat brush is marvellous for gestural, expressive patches of colour. Sometimes I move the broad face of the brush quickly across Rough paper, the speed being responsible for a very textured mark as the pigment only makes contact with the top of the surface. If I use the same colour and speed of stroke on a much smoother paper, the brush leaves its mark on most of the surface.

Rollers These deliver paint in such a way that many effects can never be repeated. A soft, spongy roller works well for watercolour, acrylic paint and ink; the pigment is absorbed completely into the sponge and you can apply more pressure as the roller moves across the support and the amount of pigment lessens. Fine, dotty areas are left behind as well as unpredictable darker, denser areas, marvellous for describing anything from beach to rocky cliff, meadow to forest.

ABOVE Marks made with a soft roller.
LEFT Marks made with a hard roller.

The hardness of a rubber roller gives a completely different character, with dots and stippled areas alongside broader marks. Alternatively, you can turn the roller on its edge and run it over the support to produce a controlled, linear mark.

You can apply some control and limit the extent of the mark with both types of roller by using a paper mask or stencil to cover parts of the painting surface you have already completed.

Tissue and cellophane These can be applied to give a very experimental and expressive painted area. They produce a broadly similar effect but there is something subtly different in the character of the mark; the cellophane leaves a slightly harder-edged appearance where pressure is applied, while tissue prints a slightly softer mark, but both can be useful for adding random textures to the work. They are both great fun to use where you do not need a precise result.

ABOVE Marks made with cellophane.

RIGHT Marks made with tissue.

Combining mediums

The mixed-media approaches demonstrated in this book use a variety of materials that are combined to produce individual and personal paintings. The interplay of one material with another requires a certain amount of acceptance of artistic accident and serendipity, allowing the materials to 'do their thing' on the support; too much desire for control can stifle creativity.

Wax crayons and watercolour

I remember using wax crayons for colouring-in at primary school, but it was a long time before I realized just how useful they would be to me an artist. Like candle wax, they repel water and so can be very effective when added to a picture prior to the laying of a watercolour wash. The watercolour immediately breaks up into separate droplets, settling only on the uncovered paper support. This is particularly useful for sketchbook drawing, where a quick added layer of wax crayon to vary the texture can transform a single-colour sketch into a more meaningful and useful rendition of the scene.

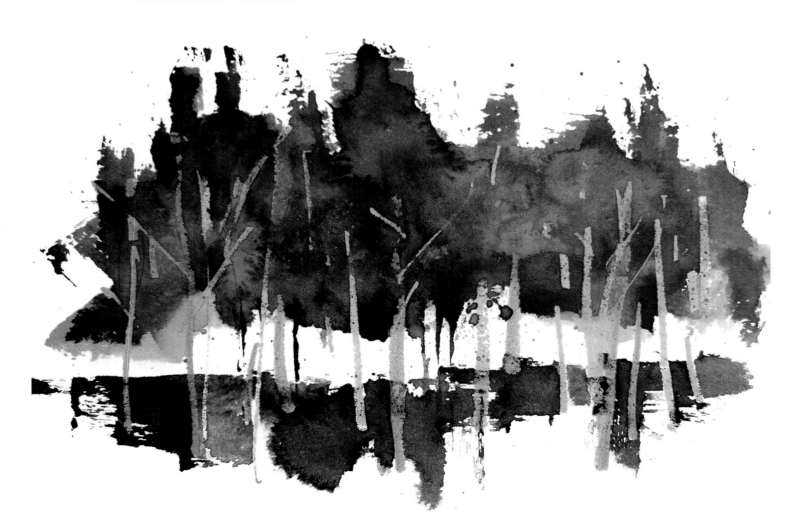

Water-soluble wax crayons

These combine with the simple non-soluble wax crayon to great effect that is again very useful for outdoor sketching, both as washes and also added later as a dry drawn mark over the top of the washes. They can be helpful when sketching outdoors using a brush or water brush and a good-quality cartridge paper sketchpad.

Watercolour and oil pastels

The discovery of oil pastels was a grand moment in my artistic development. Available in a large number of colours from several pastel manufacturers, they are sold singly or in ready-selected boxes and are offered in a variety of qualities, from student level to professional. I use a mixture of both the cheaper and more expensive brands in my artwork, and the former are usually adequate for my purposes when applied in conjunction with water-based materials. Like wax crayon, oil pastel is not a friend of watercolour and will do its best to repel all washes, allowing the paint to settle only where the oil pastel hasn't left its mark. I find this effect most useful when I want random textures in the painting. They can also be used effectively on top of both watercolour and acrylic paint and very diluted acrylic ink.

To create an oil wash, you can add linseed oil or a solvent such as white spirit to oil pastels. Spread it on your support with a cloth or brush.

OPPOSITE Wax crayons and watercolour.
ABOVE LEFT Water-soluble graphite.
ABOVE Oil pastel and watercolour.

Acrylic ink and watercolour

Ink and wash has been a well-known technique for centuries, but acrylic ink is a relatively new kid on the block. Like acrylic paint, once dry it is immovable, so you can confidently use it prior to washes without any fear of the ink marks disappearing or influencing the colour of the washes. It is sold in a large assortment of colours and many of them are very bright, sometimes benefiting from the addition of water to dilute their strength. This also means that they are more liable to break up and disperse when applied over oil pastels or wax crayon. I find the bottles a little cumbersome to take on a sketching trip so I keep my selection to very few, sometimes decanted into a lighter plastic bottle.

Acrylic paint and oil pastel

Invented in the 1940s, acrylic paint is a wonderful medium that can be diluted with various amounts of water and treated very much like pure watercolour, or used as a thick, opaque paint applied wet into wet or wet over dry in a similar way to oil paint. This gives the artist scope to include both approaches in the same painting. However, unless it is very diluted, acrylic paint will not create the same effect as watercolours when painted over oil pastel; it covers the pastel with little problem and any resist effect is disappointing. A different technique is gained instead, though, as the oil pastel has enough of a destabilizing effect on the paint that with a little coaxing, scratching and lifting of the latter the colour beneath is revealed.

BELOW LEFT Acrylic paint and oil pastel.
BELOW Water-soluble pastel and oil pastel.
OPPOSITE Acrylic ink and watercolour.

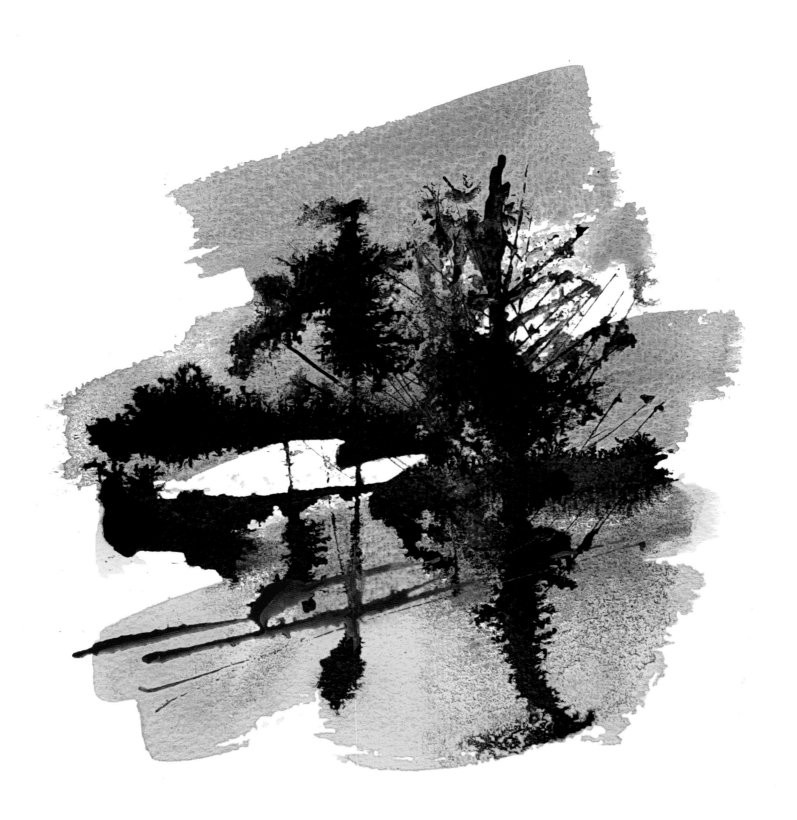

SKETCHING AND CAPTURING INSPIRATION

The importance of sketching cannot be overstated. It helps to establish real affinity with both the subject and, for the inexperienced, the materials. The state of near meditation involved in constantly looking at the subject and editing in the sketchbook helps enormously with understanding the scene before you. I tend to sketch very fast, sometimes little more than a doodle that takes just a few minutes, but on other occasions I adopt a more leisurely approach. However, even if I spend 30 minutes the result is not often a fully rendered drawing; my aim in sketching is to capture the moment and provide myself with an aide-memoire back in the studio when I'm painting.

The power of memory is often underused in painting, but the more looking and sketching one does, the better the memory becomes at retaining the subject. The great British painter Howard Hodgkin (1932–2017) very often just sat looking at the subject for hours; some might regard that as time-wasting, but on his return to the studio he had the building blocks of an abstract painting. Photographs too are an extremely useful tool to back up the artist's memory; I put both sketch and photograph together and then do another studio sketch. This gives me the chance to explore my subject further in terms of content, composition and colour and prepares me for a painting.

Any time can be sketching time, but I usually prefer to set out on an excursion with my sketching kit and my mind open to the possibility of being inspired. Once you adopt that approach, time spent on holiday, paying a visit to your favourite location or even just going for a country walk offers ideal opportunities to get out your sketching kit and make a quick but meaningful visual note of what you see.

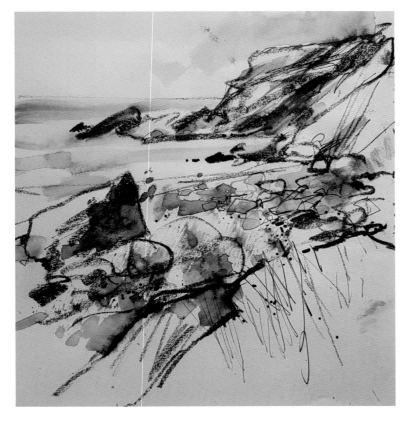

Beach with rocks

I made this sketch while I was sitting on a rock at the bottom of a cliff. I used a black water-soluble crayon, a black 0.5 fibre-tip pen and a water pen. I scribbled in an outline drawing with the crayon to capture general shapes and describe the boulders and the fall of the cliff. Next, I made a few quick sweeps of the water brush to break the initial drawing, followed by a little more crayon and then some linear description with the fibre-tip pen to show the rock-strewn beach and grassy foreground. The texture on the rock was achieved by pressing wet pigment on the palm of my hand onto the painting, an easy way of making a textural mark.

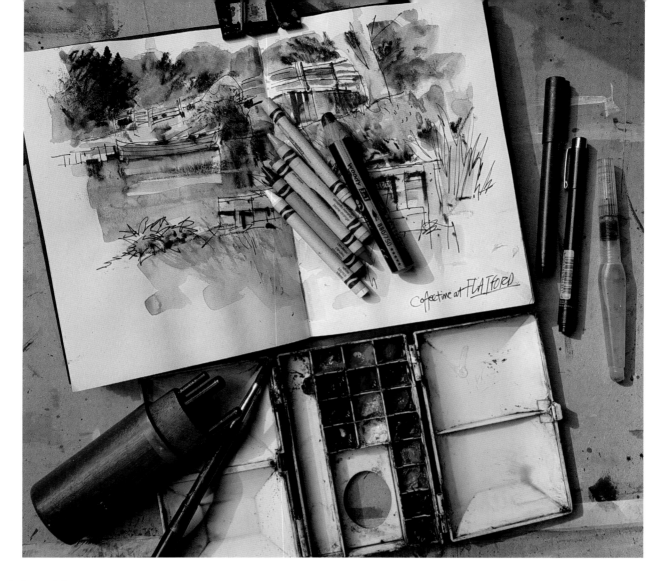

Sketching kit

My sketching kit is very slimmed down, and at a push can be carried in a pocket of my jacket, depending on the size of the sketchbook. An A5 hardback sketchbook is ideal but might prove frustratingly tiny if inspiration grabs you and you really feel the need to express yourself. This often happens to me so I tend toward a larger size – an A4 or preferably a 20 x 20cm (8 x 8in) book that opens out to give me a fairly large area for making a more complex sketch or combining a few different mediums. I carry this in a shoulder bag or small backpack, the former having the advantage of being more readily available at a moment's notice when inspiration strikes – perhaps some fleeting weather effects that will quickly be gone.

MY KIT CONSISTS OF:

· A sketchbook – hardback, not ring-bound.
· A small, 12-colour set of wax crayons.
· Felt-tip pens with both broad and fine nibs.
· Water-soluble crayons in black, blue and brown.
· A water brush.
· A set of small travel brushes (also a flat 25mm [1in] brush, not shown in the illustration).
· A small box of watercolours with refillable pans and palettes for mixing the colours.

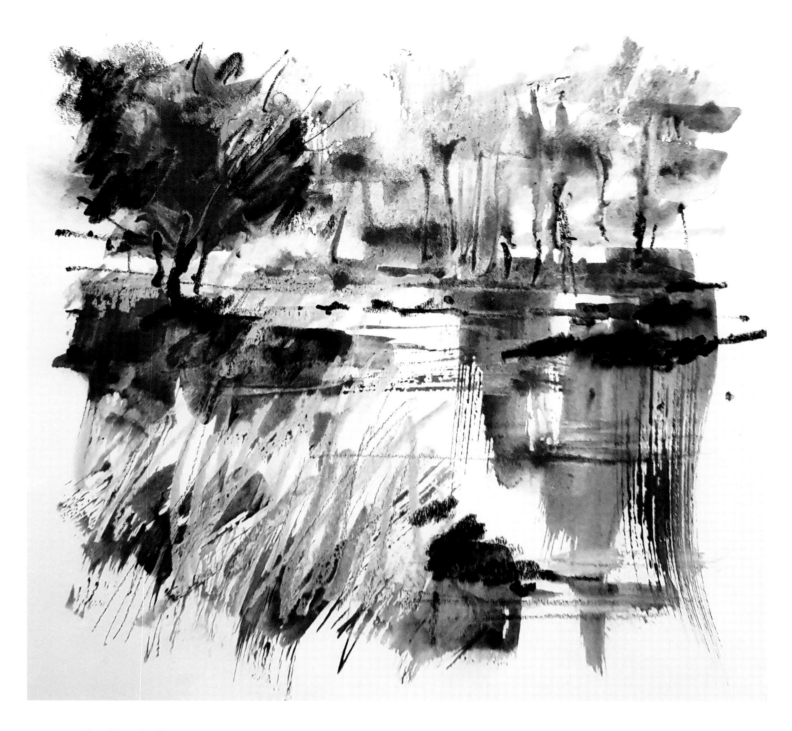

Riverside reflection

My first marks here were made using yellow and orange wax crayons to act as a resist to the watercolour. I then applied quick grey washes to indicate the riverbank, the rocks in the water and the middle-distance tree. These were swiftly followed by lighter washes for trees on the opposite bank and the reflections in the water. The sketch took me about five minutes and I later used it as reference for a large mixed-media painting.

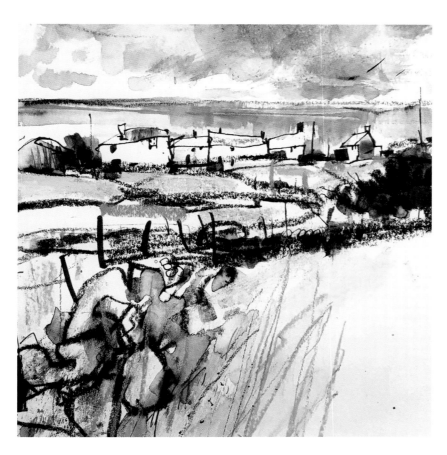

Stone wall and coastal cottages

I sketched this while sitting in the car in a lay-by on the way to the very west of Cornwall. I was attracted by the crumbling old stone wall and the line of stone cottages, some whitewashed, along the cliff. In this sketch the eye is drawn along the wall and fence posts into the hamlet, presenting a broken line of roofs and walls, chimney stacks and hawthorn bushes – simple but arresting. I used pale yellow and green wax crayons both before and after the black water-soluble crayon. To finish, I added a small amount of fine pen to describe window, door and general building detail, and also one or two telegraph poles. These are my favourite landscape features and I try to include them whenever I can, whether they are there in reality or not!

Cornflowers and golden grasses

Early morning sunshine and still, cool air encouraged a pre-breakfast walk with sketching in mind. These Tuscan hills afford fine, long views, with mountains in the distance and tree-topped hills dividing one valley from another. I drew in the blue and violet of the foreground flowers first before washing in greys and darker shapes, using water-soluble crayon and the water brush. With a fine-fibre tip pen, I made a simple record of the mountain shapes in the distance. When all of this was dry, I added pink and more yellow to describe colour on the valley fields and the range of mountains.

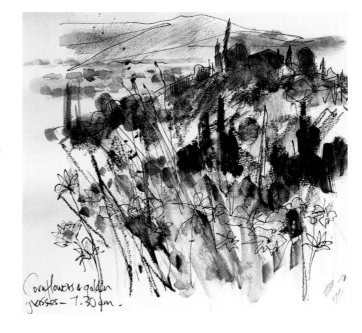

Developing a painting from a sketch

The combination of the location sketch and a photo reference or two is the ideal starting point for developing a painting. The original inspiration is captured in the sketch, and the photo is good for checking the detail and fine-tuning composition and shapes. The sketch serves as a useful aid for the memory of the scene, a visual impression that captured the moment. It is at this stage that any adjustments can be made to the composition, the painting format can be considered and, importantly, you can decide what colours to use in your palette, along with which tools and materials you would like to combine in your mixed-media painting. It can be a very good idea to make another little compositional sketch before starting the painting, which can help with tones and composition, and adding a tiny colour swatch next to it can help finalise your colour decisions, reassure you on your planning and, hopefully, prevent rethinks while you are doing the actual work.

Capturing the moment

A long, leisurely stroll on an Australian beach on a warm and sunny day gave me ample opportunity to observe the scene around me. Resting on a boulder at the back of the beach, I found the scene in front of me took my fancy and taking out my sketchbook and box of watercolours I quickly made a small, sketchy painting and a monochrome sketch to help me understand both tones and colours. The light was intense and I wanted to capture the colours in the rocks, shadows, shallow waters and cliffs, and the fun being had by the small figures on the top of the table-top rock. I also took a couple of photographs on my smartphone, and having captured the scene adequately I continued on my stroll.

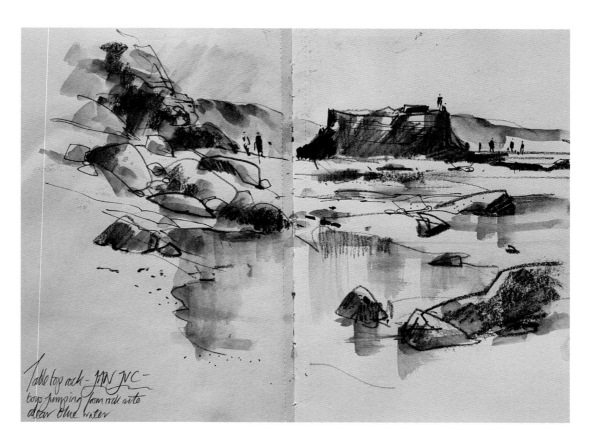

Sketches and photographs

The black-and-white sketch (opposite) was made using a water-soluble pencil, a felt-tip pen and a few loose washes of tone from a water pen. This provided an adequate amount of clean water in its barrel, enabling me to release some of the pigment of the water-soluble pencil and provide a soft, light grey wash. The important elements to me were the deep shadows and unique flat profile of the rock, and the dark shadows cast from the orange sandstone boulders. The tonal contrasts in the sunlight were intense, but the photograph that I took on my phone was a lot less useful than I anticipated – the colours were bleached and the scene lacked what I saw in it as I sat contemplating its drama. It did help with the detail, but my sketches were much more useful.

This tiny colour sketch (right) was little more than a doodle painted from the same spot with the intention of capturing the vivid quality of the Australian light in a simple and loose way. It took less than 10 minutes, but by combining the information from this and the black-and-white sketch I could see the possibilities of a painting in mixed media that could be painted later, when a little shade was available.

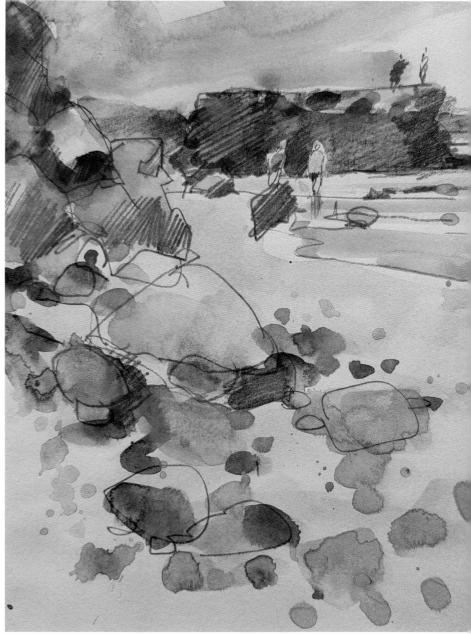

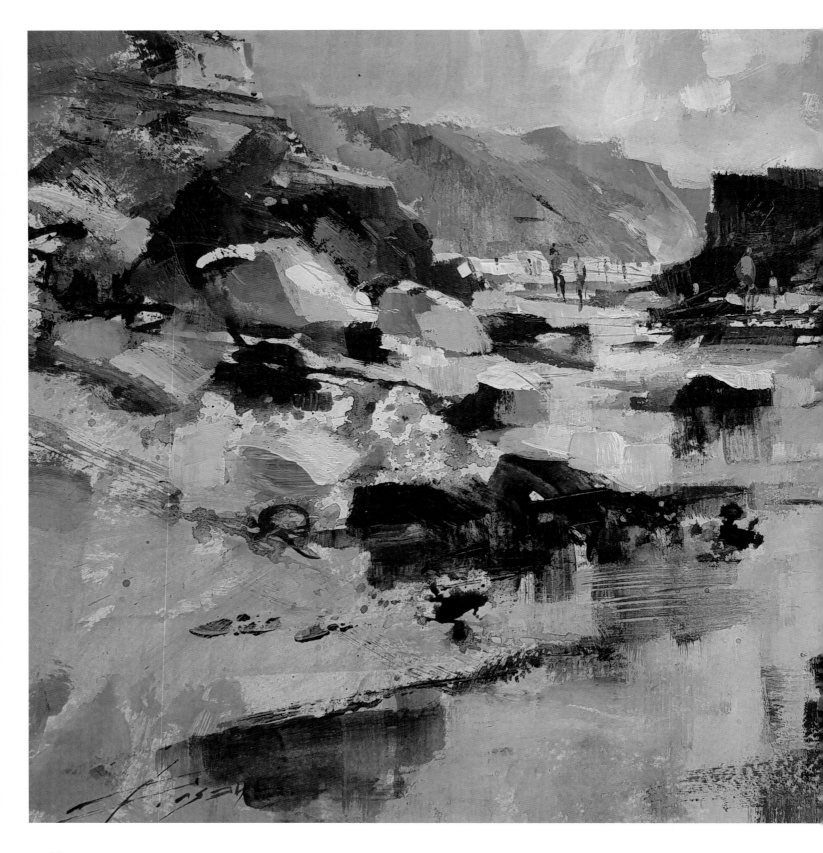

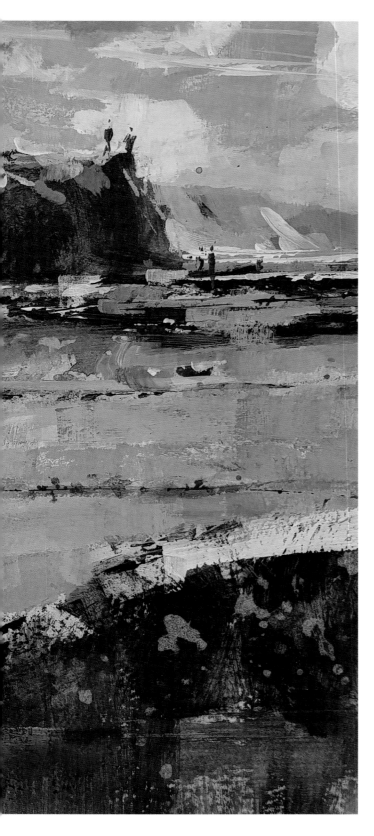

The painting stage

In the shade of a porch at my accommodation I began to paint later that day, while the scene was still fresh in my mind. I used a little artistic licence with my composition by introducing a shallow pool of water in the foreground. This added more colour contrast between the rocks and sea and helped the composition by introducing a foreground to middle-distance route into the painting.

I chose a combination of Purple Lake acrylic ink and acrylic paints in Cadmium Orange, Cadmium Red and the complementary colours Cerulean Blue and Turquoise to make maximum colour impact and capture the strong sunlight. I washed in an underpainting of orange first, and when that was dry I painted the darker parts of the scene using the purple ink, sometimes dispensing with the brush and using the pipette from the top of the bottle. Next I completed the rocks with dashes and small blocks of red, orange and mixes of purple ink and red acrylic. I blocked in the sky with mostly blue and white paint and purple ink mixed with white for the sky area, then used blue and turquoise paint for the shallow pools on the beach. Finally, I dotted in small figures, bringing this Australian summer scene to completion.

Rocks and Shallow Pools
25 × 35cm (9¾ × 13¾in)
Acrylic paint and acrylic ink
on acrylic paper

Beginning a landscape painting

I have been a landscape painter for my entire career as an artist. The subject matter is endless, which makes the genre endlessly satisfying, but it can present a difficulty: with all that choice, where does one start? Selection of your subject matter is at first a challenge. A camera is obviously be a useful piece of kit for looking at a variety of framed compositions, but the humble thumbnail sketch can also be a great help. Doodles in a sketchbook, no matter how simple, have an advantage in that much of the editing of the scene has already been done, with the subject matter, viewpoint and main elements all selected. The artist has also spent some minutes looking constantly at the scene and then simplifying it, meanwhile committing a great deal of it to memory, which will help enormously when making the painting. The more you look and sketch, the better your memory will become at summoning up colour, mood and atmosphere later.

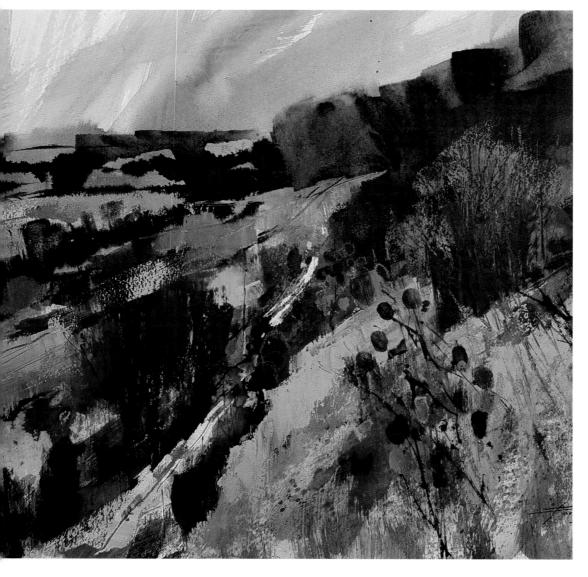

Downland Scarp
40½ × 40½cm (16 × 16in)
Acrylic paint, watercolour, acrylic ink and oil pastel on acrylic paper

One of my favourite local views. I like the dynamic structure with the diagonal sweep of the tree line and strong, dark shapes, the chalky path cutting across and the simple colour scheme of Payne's Grey, Burnt Umber, Yellow Ochre and just a touch of pale green in the distant fields.

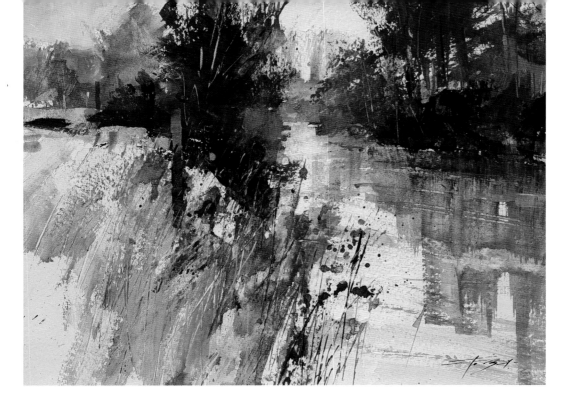

Riverine Sunrise
35½ × 40½ cm (14 × 16in)
Acrylic paint and acrylic ink
on acrylic paper

This painting was taken from a quick sketch, and a simple palette of Dioxazine Violet and Lemon Yellow was chosen to give a colourful, atmospheric image of early morning by the river.

What are you trying to express?

My particular inspiration as a landscape painter very often comes from the atmosphere, the colours and times of the year or day, and of course the weather. I recommend asking yourself the following questions before getting anywhere close to starting the painting. First, what inspired you? When looking at a landscape, what is it that has captured your interest? This is, to my mind, the most important aspect of the creative journey of a landscape painter.

Structure Is it the structure of the scene that took your eye, perhaps with shapes interlocking, overlapping, creating spatial distance as they diminish in size?

Colours Is the range of colours in a landscape stimulating and exciting as contrasts and harmonies fight for your attention? The palette of colours varies during the year, with the sharp yellows, pinks, violets and blue of spring, strong deep greens, purples and orange of summer and then the autumnal range of warm reds, oranges and russets. Winter is a time I like best for landscapes, with its greys, indigos, browns and magenta. They may not be to everyone's taste, but they can look marvellous in a painting.

Mood and atmosphere The time of day, the season, and the weather conditions play a huge part in altering the perception of a landscape. Structure and colour can be affected by mist, rain and snow and aerial perspective is enhanced, meaning that elements in the middle and far distance are less distinct, contrast and colour are reduced and the illusion of distance is increased. Also, the angle of sunlight plays a huge part in strengthening the atmosphere of the scene.

Format

Probably the most basic decision to be made before embarking on a painting is what shape, or format, you want the composition to be. Of course it is possible to alter the shape of the painting after it is finished, but if it is on board or canvas, that can prove a lot more difficult than a work on a piece of paper. It is usually best to make a considered decision before your brush touches the surface of the support and you begin the painting.

The choice for landscape is usually a rectangular landscape format, that is, broader in width than height. This can always be turned to make it portrait format – narrower in width than height. However, it can be interesting to use square format or a letterbox shape of extended horizontal length and reduced height. Some subjects can be radically enhanced by a change of format.

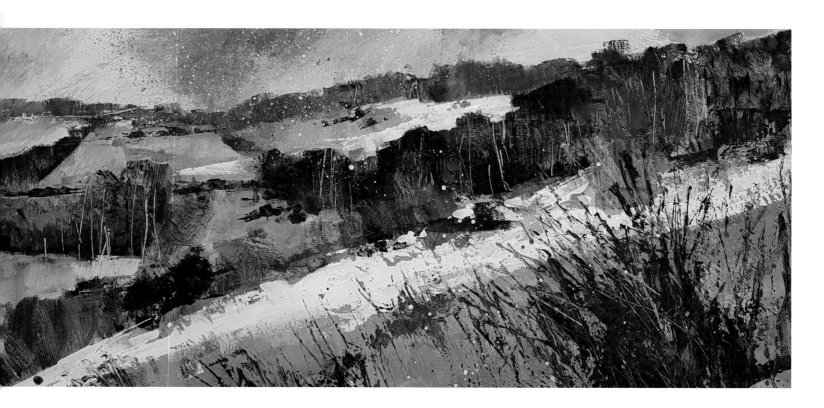

Winter Downland

31 × 59cm (12¼ × 23¼in)

Acrylic paint on gessoed board

The letterbox format, a slightly elongated, landscape-shaped rectangle, is perfect for broad, sweeping landscapes where the eye is encouraged to take a leisurely journey through the painting, wandering from side to side and moving slowly into the heart of the landscape. This format was perfect for a painting of snow-covered downland where no obvious focal point is grabbing the attention. You can just stand and enjoy the view.

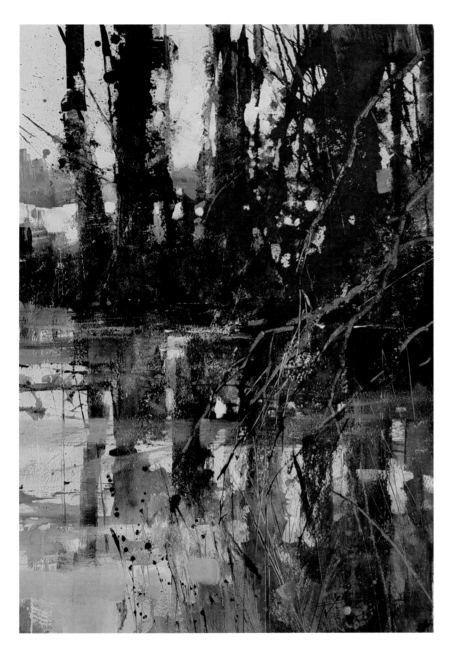

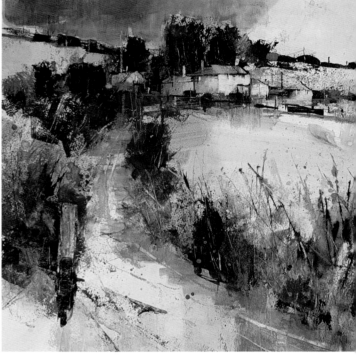

The Path to the Farm

40 x 40cm (15¾ × 15¾in)

Watercolour paint on Not watercolour paper

For this painting I chose a square format to add a certain visual dynamic to the path, taking the eye up to the farm buildings placed high in the picture and very close to the horizon. I often choose this format as it gives the painting a more contemporary and dynamic feel, adding impact to the work. The eye seems to travel around the shape comfortably and it seems to work well with subjects that have a high horizon and those with a T-shaped composition. It can also be useful for paintings that have a zigzag composition and plenty of foreground.

Tree Silhouettes and Reflection

48 × 32cm (19 × 12½in)

Acrylic paint on acrylic paper

Tall, straight tree trunks caught in silhouette against a bright sky made a good subject for the portrait format, which allowed full exploitation of the reflections and verticals in the scene. They are interrupted only by the few diagonal branches and flashes of orange in the foreground.

Composition

'Composition is the art of arranging in a decorative manner the various elements which the painter uses to express his sentiments.'

Henri Matisse (1869–1954)

If as artists we look long and hard at a painting that fails to satisfy us, more often than not we will realize that a compositional element is letting the work down. The composition of a painting refers to shape, colour, tonal values, positioning, rhythm, balance or imbalance and harmony – some of the same elements that a composer has to consider when writing music. When we sketch we tend towards simplifying the shapes and elements in the subject, and this helps with the final painting as it breaks up complicated shapes into simpler elements and gives our work a structure.

The classic composition is the division of a landscape into thirds, with the focal point on the crossing of horizontal and vertical axes – a failsafe design. The focal point may be an object or group, a strong dark or light shape, the most vivid colour and so forth. The zigzag is a useful compositional device as it is a good way to lead the eye into a painting on a visual pathway. Very often a winding river can provide a compositional opportunity of this type; a fence line or hedgerow across fields or a meandering path or track can do the same thing. They don't necessarily need to conform to a zigzag shape, but a pathway that turns and changes direction is of more visual interest than an unfaltering straight line.

The overlap of shapes also helps to build depth into a painting, using trees, bushes, hillsides, rocks and cliffs, their relative size informing the viewer as to the distance between them. Conversely, sometimes a stretch of landscape or a coastal scene can be of visual interest in its banded layers and would lend itself to a more stratified composition, for example, a view across a ploughed foreground field to a line of trees, with above and behind it a hillside with a bright green field meeting another narrow line of trees, and above that scrubland and a silhouetted line of tall fir trees on the hillside ridge. The composition for any scene can be combined with aerial perspective to provide maximum depth in a painting.

If a painting is too formally balanced, with the same sizes and shapes on both sides of the picture, it can look a little boring, like candlesticks on a mantelpiece. A more interesting composition can be achieved when sizes and shapes are placed in a more imbalanced way, a bigger shape balanced by a corresponding small shape on the other side.

Classic thirds

This is always a good compositional set-up and has been used many times throughout the history of painting. It suggests a dominant horizontal and vertical, possibly the horizon and a landscape feature.

Zigzag

A very good way to lead the eye into the picture, taking the viewer from foreground to background. A zigzag can suggest a path, road, fence, stream, coastline or beach.

Overlaps

This composition offers the viewer a partly obscured landscape view, like the scenery on a stage, inviting the gaze to be curious about what is behind each overlap. It could be trees, buildings, rocks or something else.

Strata

A good composition for possibly a more abstracted painting that relies on texture and colour. It is good for creating distance, for example field divisions or views across coastal land to the sea.

COLOUR

The choice of colours will have a real impact on the mood of a painting and also the dynamic, exciting the eye with the visual impact. A basic knowledge of colour is essential to achieve successful mixes and combinations – a lot of time and paint may be wasted otherwise. Artists usually develop their own selection of colours that they prefer and then choose from them for specific paintings. The following colours are in my own basic palette.

Blues
Cobalt Blue
Prussian Blue

Yellows
Cadmium Yellow
Cadmium Yellow Deep
Lemon Yellow
Quinacridone Gold

Reds
Cadmium Red
Quinacridone Magenta
Cadmium Scarlet

plus
Titanium White
Payne's Grey
Raw Umber
Raw Sienna
Yellow Ochre
Dioxazine Violet
Cadmium Orange
Turquoise
Pale Olive

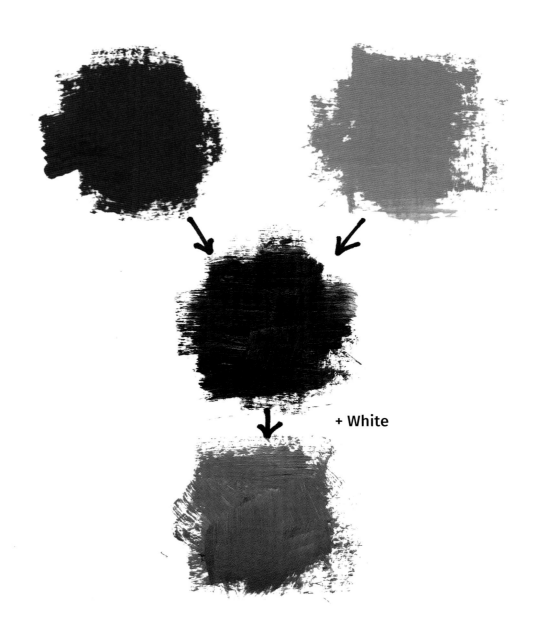

+ White

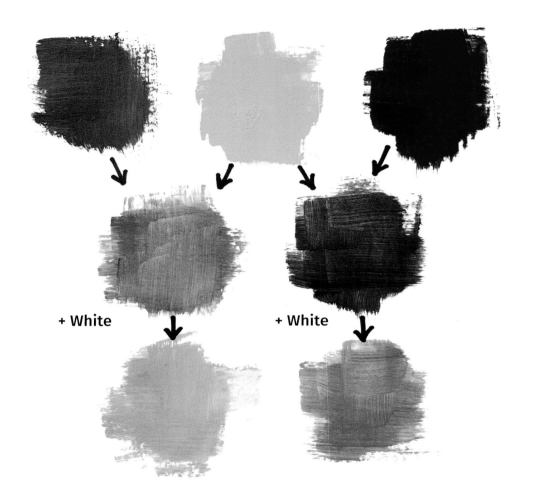

+ White

+ White

A simple, straightforward mixture of two or three colours can provide a surprisingly large range of hues. Orange and blue, for instance, can create a brown, which with white added gives you a big range of colours. Likewise, Dioxazine Violet mixed with Lemon Yellow makes a brown, and Lemon Yellow mixed with Payne's Grey creates a very useful green. These few colours can easily provide enough colours and tones to paint many a landscape.

From these colours, I then select a 'family' of usually no more than four or five colours that I mix together and juxtapose to create the desired effect in a painting. I have examples of tried and trusted palette combinations in both acrylic and watercolour on my studio wall; sometimes the names are a little different but they are basically the same hue with the same colour characteristics. My oil pastel selection is also very similar.

A representational combination of colours in a painting to describe the world around us can be just as exciting as using a more personal or heightened colour choice. For the former approach you will need to spend a lot of time observing the exact colours of the scene and thinking how to achieve them on your surface. Painting the scene on location is an advantage as you can constantly assess the hues to arrive at an accurate representation.

If you are going to make your painting at home, accurate and specific note-taking on location can help a lot. The camera is also a very useful tool, and most artists use them, to a greater or lesser degree. They can, however, apply a little distortion to colour, sometimes altering the colours to appear sharper in sunshine or greyer if there is cloud. The eye is a better tool for seeing subtle colours that the camera doesn't read. Perspective can also be altered: most smartphones, tablets and compact cameras distort to a degree as the lens, usually 35mm, doesn't read the scene in quite the same way as our eyes. However, a certain amount of artistic licence is almost inevitable, and a considered interpretation of the landscape colours gives the work extra creative content.

Green landscapes

It's common for artists to describe green as 'a difficult colour', and indeed it took me some time to start enjoying green until I began to understand how to use it more effectively. Of course, to refer to green as if it were just one colour is a little misleading, as it can range from a yellow-based colour to a blue-green at the other end of the green range.

A painting subject that contains a lot of green can prove a challenge. I rarely use tube green and would prefer to mix my greens from other colours that I want to use in the painting. Obviously the choice of colour will have a big effect on the green that is mixed.

A helpful rule of thumb for selecting the right colours to mix a green is to consider whether you want a bright, sharp green. If you do, make sure that the yellow has a green edge to it, such as Lemon Yellow, and the blue has a slight green tinge, for example Cerulean Blue. These two colours mixed together will make a bright, fresh green, perfect for spring. However, if you are looking for a yellow-green, mix Cadmium Yellow Deep or Cadmium Orange with a blue such as Ultramarine, which is a warm blue with a slight red tinge, to make a duller, warmer green.

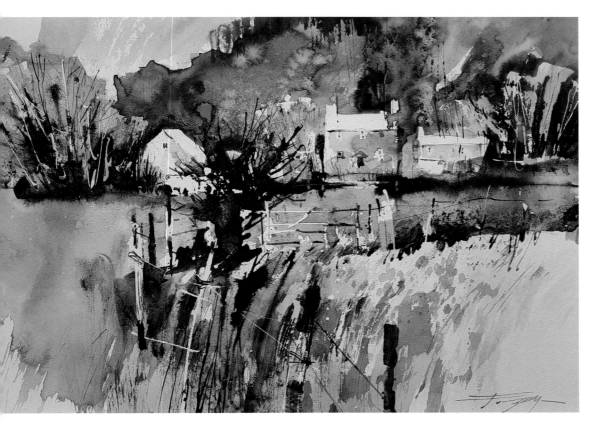

The Arun Valley and Cottages 1
25 × 35cm (9¾ × 13¾in)
*Watercolour and acrylic ink
on Not watercolour paper*

In this simple watercolour and ink landscape, I used only Lemon Yellow and Payne's Grey paint and Indigo acrylic ink. The result is a fresh set of greens that hint at spring or early summer. I encouraged the paint colours to mix on the paper to create a cool green and also a brighter yellow-green in places. Into this damp wash I added ink in loose, descriptive marks that hint at trees, shadows and longer grass, letting the ink spread a little to release a brighter blue as it mixed. This accidental effect adds a little more visual excitement to the basically yellow-green painting.

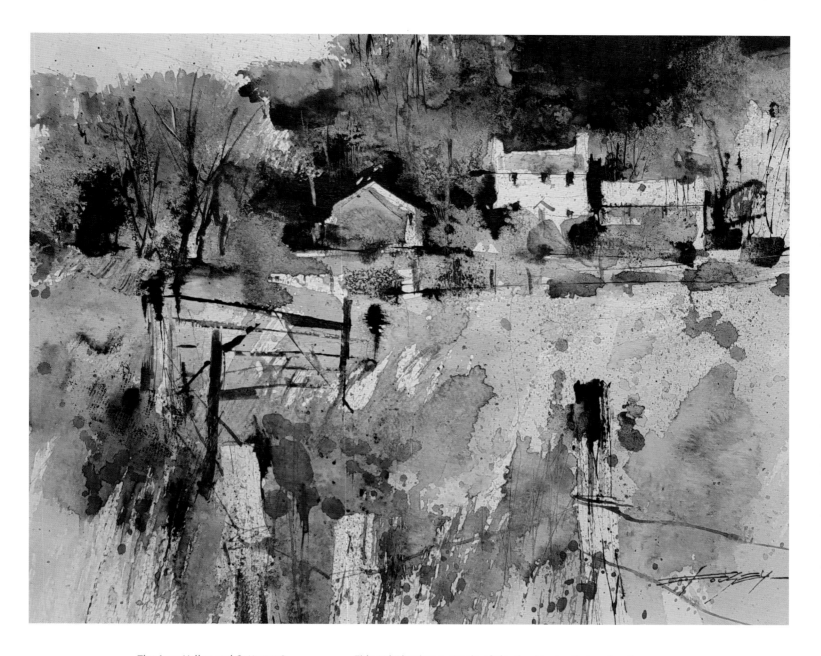

The Arun Valley and Cottages 2
25 × 35 cm (9 ¾ × 13 ¾in)
Watercolour and acrylic ink
on Not watercolour paper

This painting has a couple of simple changes that makes the scene autumnal. I used Quinacridone Gold watercolour along with Lemon Yellow and Payne's Grey for the darks, which when mixed with the gold creates a very effective green/brown and gives the painting a different mood. The greens are a little more muted and subtle, perfect for an autumn painting.

Imaginative colour

The language of colour is endlessly fascinating, and it is possible to change an ordinary landscape into a real *tour de force* by using an imaginative combination of colours to describe the scene. Great creative fun can be had by heightening the colours that are already perceived to be in the landscape; greys can be interpreted as violets and blues, browns as reds and russets, greens as yellows and oranges, and so forth. An understanding of colour is helpful and combinations can be derived by looking at the colour wheel (see page 40). You may want quiet harmony or vivid, startling combinations; it is for you to decide which palette of colours to use according to your plan of the painting.

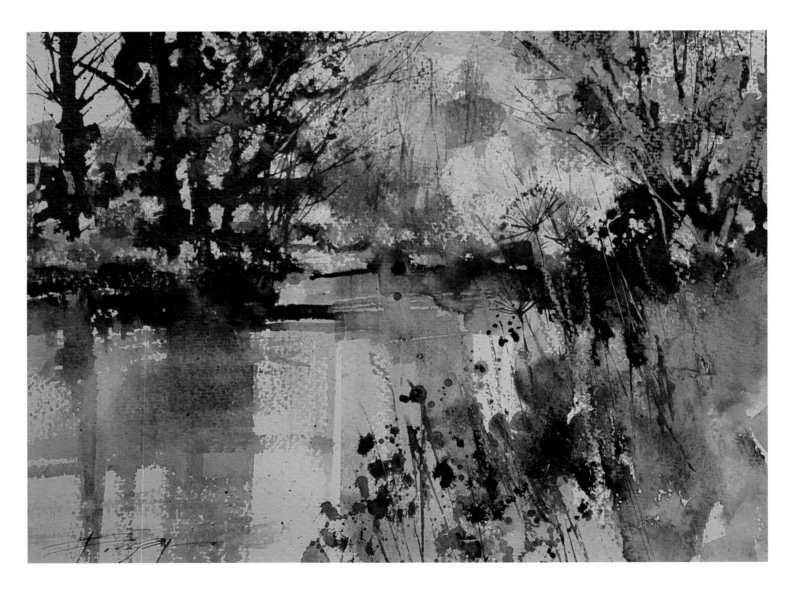

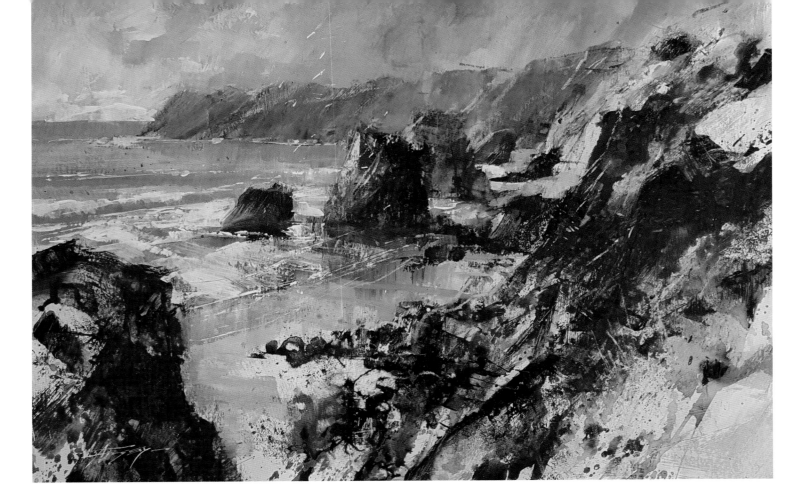

OPPOSITE **Autumn Pond**
25 × 35cm (9¾ × 13¾in)
Watercolour, acrylic ink and oil pastel on Not watercolour paper

This pond had taken on a magical appearance as the leaves turned in October. The golden glow of the trees was painted with Quinacridone Gold watercolour, and as it dried I dragged a pipette laden with Antelope Brown across the shapes, forming very loosely suggested trunks and branches. Again, before this was completely dry, I spattered more ink in both Antelope Brown and Cadmium Orange onto the tree and the bank, allowing the colours to run together to create unpredictable shapes. To add to the colour I then added hints of oil pastel in pink and purple to boost the colour content, followed by skeleton shapes of umbellifers in the foreground.

Late Sunshine, Bedruthen Steps
25 × 35cm (9¾ × 13¾in)
Acrylic ink and oil pastel on gessoed mountboard

This painting relies heavily on the juxtaposition of two complementary colours, yellow and purple. I let the Dioxazine Violet and yellow mix in some areas to produce a brown, which, mixed with the purple on the paper, created excellent dark passages for the cliffs in the near distance. A touch of white paint was mixed with it to lighten the tonal contrast of the cliff stacks in the middle distance in comparison to the foreground. I also added a Prussian Blue to the palette, which was useful for describing the distant headland, golden clouds and blue-tinted cliff. I couldn't resist adding a broad stroke of yellow pastel to the foreground grasses and also to the sunlit edges of the cliffs. I wanted to produce a dramatic rendition of this scene, and using both aerial perspective and complementary colours I pushed representational colours to the extreme.

Non-representational colour

Being experimental with colour can give rise to one of the most exciting and creative journeys in painting. Understanding colour and how to use it to its full potential to extend your work beyond the purely representational may be a lifelong but endlessly fascinating process. A study of the colour wheel principles will help you to get started.

The colour wheel

The colour wheel is a guide to your choice of colours to include in your palette. Example: using an orange oil pastel under or over the top of a green/blue such as Phthalo Blue uses some of the impact of complementary colours, that is choosing two colours from opposite sides of the colour wheel. The scumbling of the pastel on top of the paint allows the other colour to show through, creating an interesting area of texture and colour.

Treeline and Meadow
20 × 40cm (8 × 15¾in)
*Watercolour and oil pastel
on Not watercolour paper*

This little painting, completed on location in a French riverside meadow, relies on the two complementary watercolour pigments Blue Purple and Lemon Yellow. I also used a yellow oil pastel to describe the sunlit trunks of the trees with just a few broken strokes. This combination of colour invariably brings the feeling of sunshine into a painting.

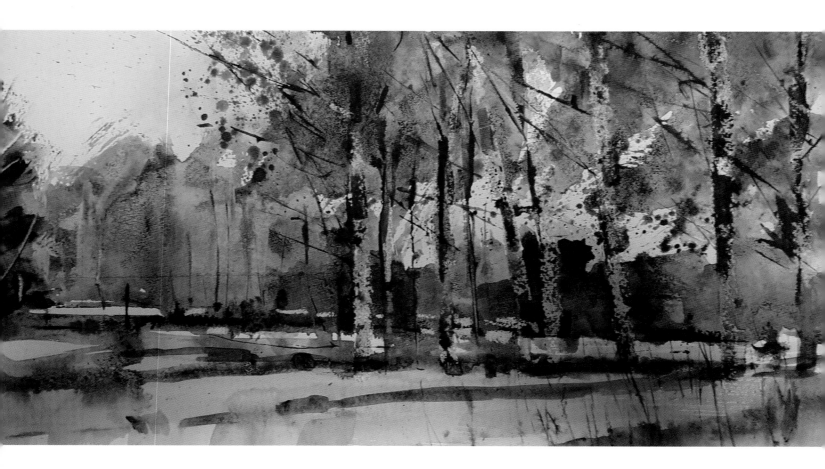

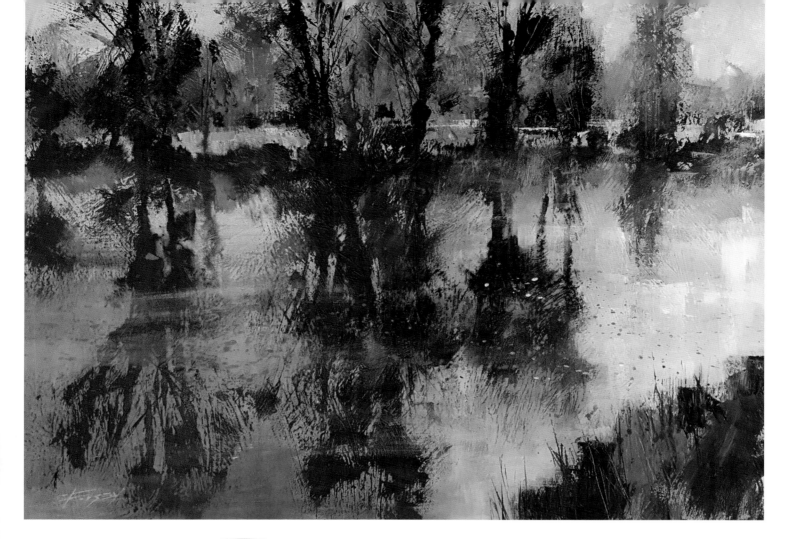

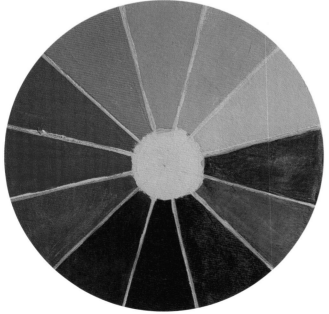

River Reflections

50 × 60cm (19¾ × 23½in)

Acrylic paint and ink on canvas

By raising the horizon to the top third of the picture, I have given myself a large expanse of water in which to concentrate on the reflections as much as on the trees themselves. The combination of Yellow Ochre and Indigo acrylic paint and Payne's Grey acrylic ink creates a visually textured painting relying on the silhouetted tree shapes and thin veil of leaves on the trees for its impact. The two colours have mixed in places to create an umber brown, making a subtle colour addition to the composition.

Reeds and Riverbank

28 × 40cm (11 × 15¾in)

Acrylic paint and oil pastel
on acrylic paper

This painting relies once again on the strong use of complementary colours, but with a subtle difference: I used two complementaries, Prussian Blue and Cadmium Orange, and added two extra blues, Ultramarine and Turquoise. Here a combination of three harmonious colours benefits from the general complementary colour adding some visual excitement.

Wooden Bridge

50 × 60cm (19¾ × 23½in)

Acrylic paint and ink on canvas

I chose a small group of harmonious colours for this autumnal scene – Lemon Yellow, Cadmium Yellow Deep and Raw Umber. These three hues work together to create a peaceful mood, with a few additions of Indigo to boost the darker shadowy areas and, mixed with white, to show the sky and lighter shadows. The brown acrylic ink was applied to describe the bare tree branches and foreground grasses and stalks. I dipped the edge of a palette knife into the ink and pressed it onto the support, then spattered a few drops of water onto the ink to break up some of the harsh lines and create a slightly more natural look.

St Michael's Mount 1

28 × 40cm (11 × 15¾in)

Acrylic paint on acrylic paper

This little work uses two colours, Ultramarine Blue and Cadmium Orange. The brown is mixed from them and creates a strong, dynamic dark.

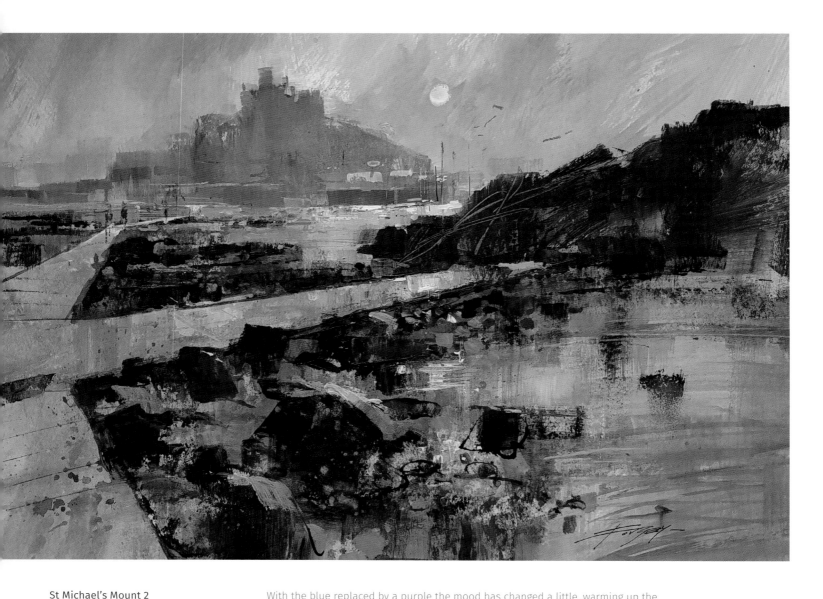

St Michael's Mount 2
28 × 40cm (11 × 15¾in)
Acrylic paint and water-soluble crayon
on acrylic paper

With the blue replaced by a purple the mood has changed a little, warming up the slightly cool atmosphere of the blue and orange painting, making it more reminiscent of a warm autumn day. The touches of green are a strong addition and help to bring the foreground rocks nearer to the viewer. These two paintings show how a subtle shift in mood can be communicated by changing just one of the hues used.

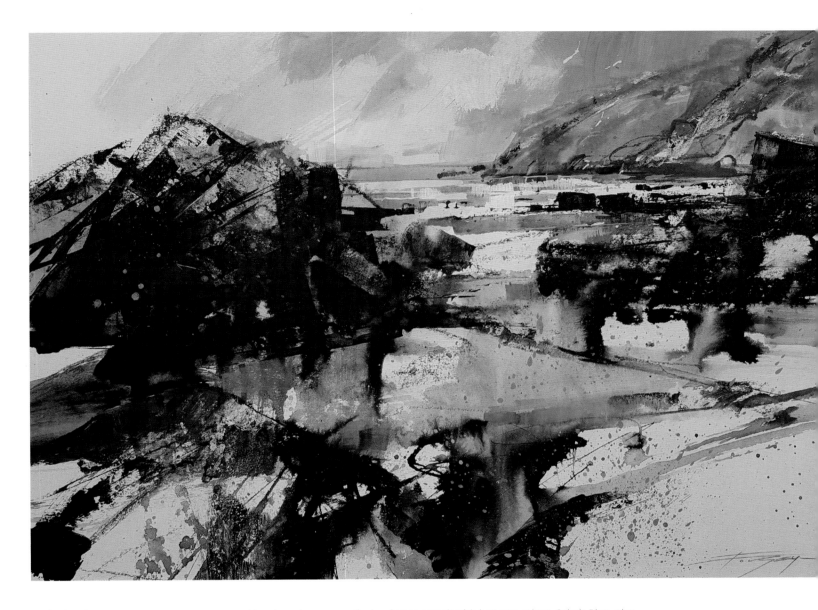

Rocky Seashore

35½ × 45½cm (14 × 18in)

Watercolour, ink, and water-soluble crayon on acrylic paper

Here I used an energetic drawing approach with just one colour, Cobalt Blue, plus black. This gives the painting a pleasingly loose, expressive quality. The blue has been used sparingly, allowing the black graphite to create strong shadowy, textured areas, which are more a suggestion than fully realized. The preservation of some white paper was vital to keep this work light-filled. The blue helps to create the feeling of depth, with just touches of blue and black water-soluble crayon used to add a few bits of detail in the background cliffs, drawing into the wet watercolour and allowing it to spread and blend. I let black acrylic ink drift and mix with the watercolour, creating a nice granular appearance in places. I also used black ink to spatter into the foreground to add further texture to the work.

Colour contrasts

The colours you use in a painting hugely influence the mood and atmosphere created in the work, and decisions need to be made from the outset as to what one is trying to convey. These two paintings have highly contrasting colours that set a mood. One painting has a warmer feel, while the other seems fresher. Both have different yellows and a cool and a warm dark. The first painting was made in late morning on a warm day, and the second in a fresher early morning. This contrast is conveyed well in the paintings, I think.

Riverside, the Tardoir 1
32 × 48cm (12½ × 19in)
Watercolour, ink and oil pastel on acrylic paper

This scene is done in quite representational hues, but slightly heightened in intensity. I used Indigo and Quinacridone Gold watercolours and Antelope Brown acrylic ink. I also included a little oil pastel to break up the washes and add some texture.

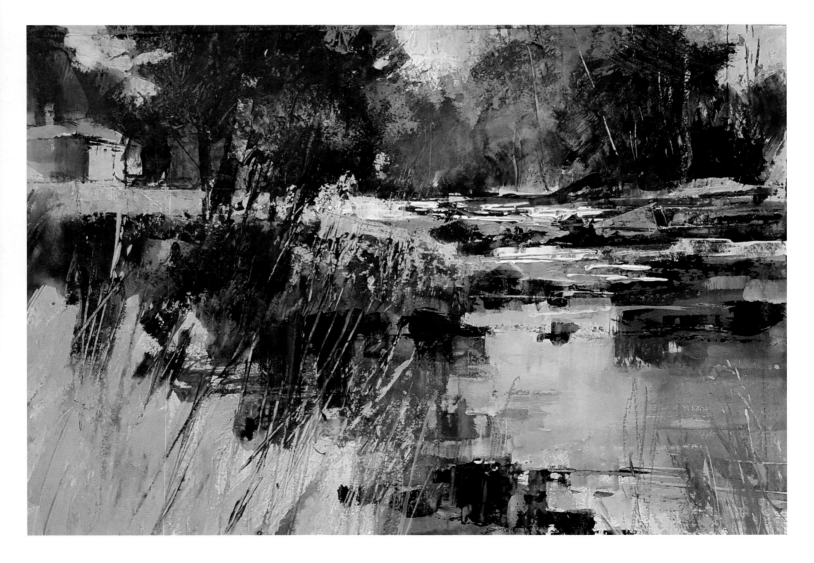

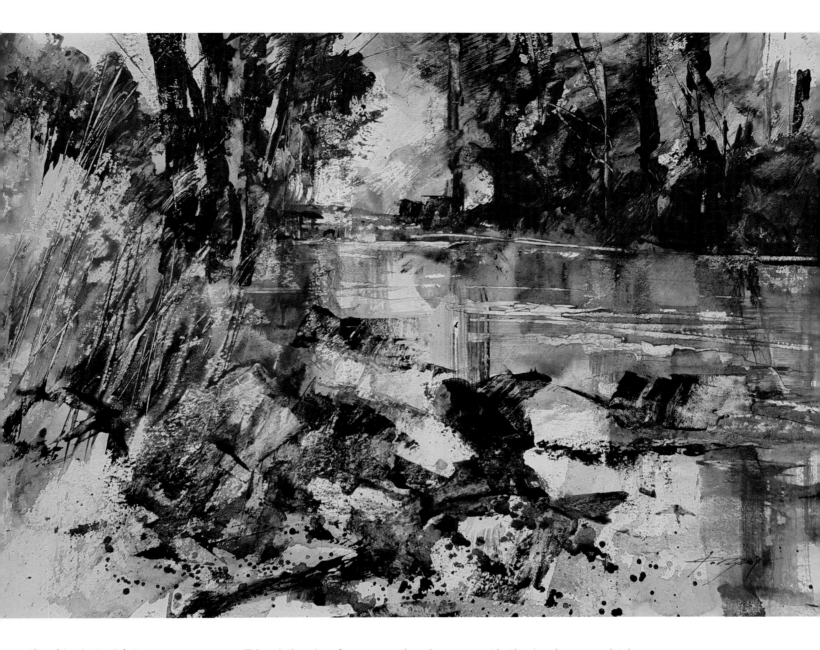

Riverside, the Tardoir 2
30 × 40½cm (12 × 16in)
Oil pastel and acrylic ink on acrylic paper

This painting, done from more or less the same spot by the river, has a completely different pairing of complementary colours. Here I chose Lemon Yellow, Dioxazine Violet and Payne's Grey, with small touches of Titanium White. The yellow and purple mix together to make a warm brown, very useful for the darker parts of the painting. The Payne's Grey adds a cooler tone to the scene and was useful for the shadows on the rocks and boulders and the upright tree shapes, contrasting tonally with the bright yellow foliage.

THE SEASONS AND WEATHER

The changing seasons have a great effect on the colours and general appearance of the landscape; the palette of colours that may have served you well in winter can prove disappointing when you try to paint a convincing spring or summer scene with them. I find the colour choices can be quite radically different with, for instance, the lack of green in winter, a powerful and acid green in spring compared to the warmer gold-green of autumn, and of course the summer is full of greens – strong, deep and varying from one extreme to the other, dominated by yellow or blue.

Of course green is not the only variant, and I tend towards a neutralized winter palette, with lots of greys and purple-browns, and a far more colour-saturated group of colours for spring and summer. A lot can be learned by examining the best of the Impressionist painters and their renditions of colour throughout the year. Probably the most useful artist in this respect is Claude Monet, with his marvellously exciting and complex combinations of hue to show the same scene through the seasons. However, there is no doubt that the observation of the landscape itself is the key to success in your seasonal representation of a scene.

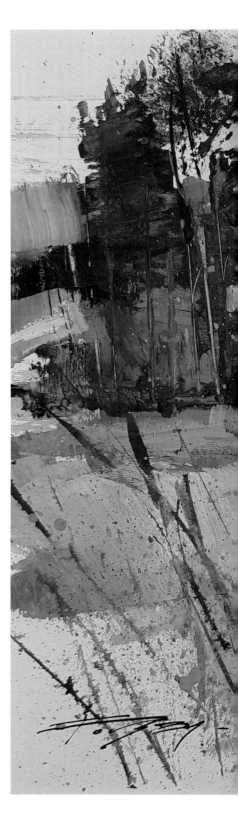

Winter Fields

22 × 33cm (8½ × 13in)

Acrylic paint, acrylic ink and oil pastel on acrylic paper

This winter landscape was inspired by the late afternoon light casting a blue coolness over the scene. I began with a very pale Cadmium Red wash, however, to lend a certain underlying warmth to this otherwise cold painting. I chose Cadmium Red, Raw Umber, Prussian Blue and Titanium White acrylic paints, mixing the red and blue together to make a strong, cool dark, and used the Burnt Umber acrylic ink to describe the foreground branches, adding spatters in pale Prussian Blue and white to depict a few snowflakes. I also used Yellow Ochre and Scarlet oil pastels to add a few branches and describe the odd tree trunk in the distant woodland.

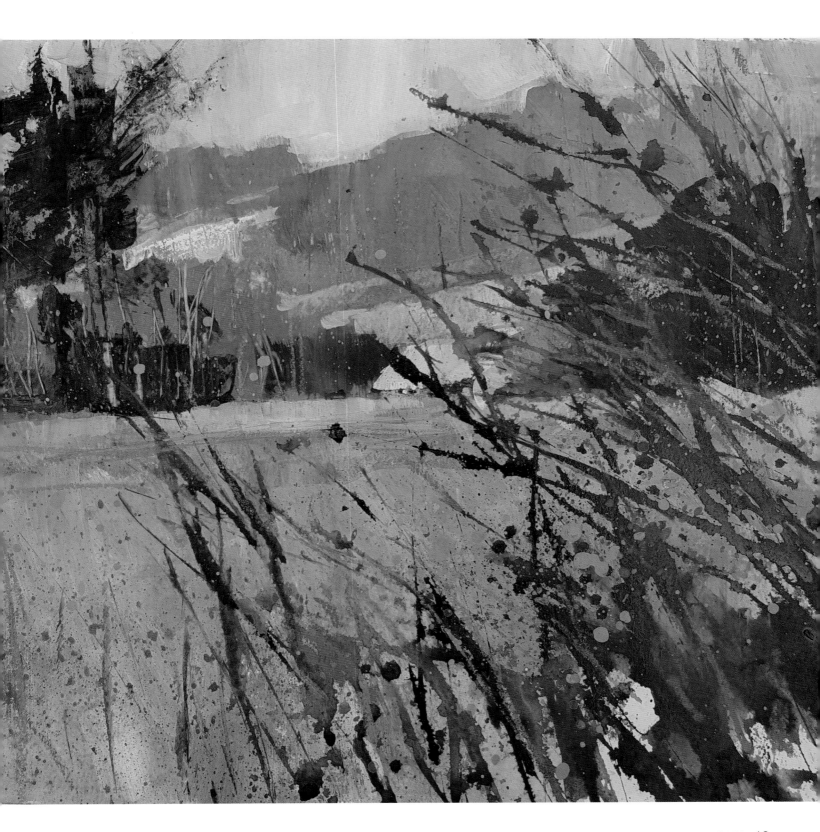

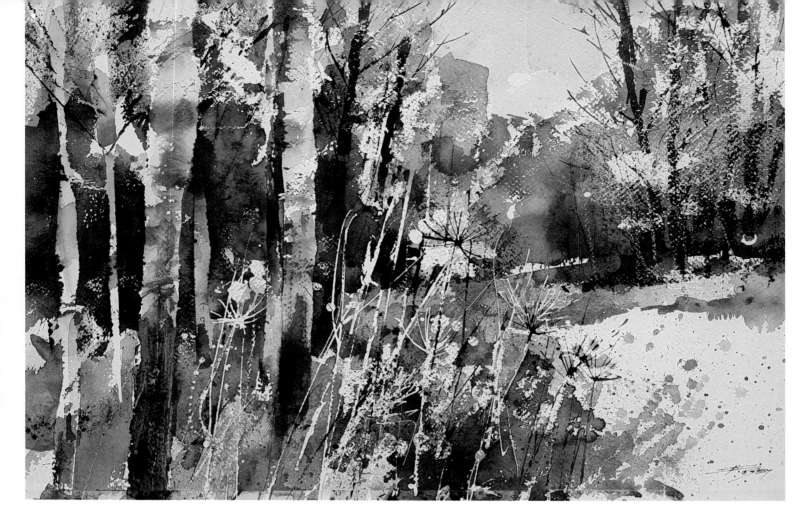

Winter

Although the winter landscape tends to be sombre and austere, lacking in colour, this can prove to be the most inspiring time of the year. Although it is not always a time when plein-air painting appeals, it is feasible to grab photographs and make a quick sketch to be turned into a painting back in the warmth of the studio. The trees are reduced to skeletal shapes, their branches and trunks silhouettes against the background, which can be very inspiring and enjoyable to render in mixed media.

Winter Woodland
30 × 46cm (12 × 18¼in)
Acrylic ink, watercolour and oil pastel on Not watercolour paper

The first thing I did here was to mask parts of the trees with loosely applied, broad areas of white oil pastel and masking fluid to act as a resist. I also masked out the finer branches and some of the foreground twigs. I used a very pale wash of Yellow Ochre in the sky and a darker wash of this colour on the brown, grassy area in the middle distance. I then brushed on very loose washes of Indigo, Prussian Blue and a small amount of Dioxazine Violet to indicate more trees and shadows. Once these areas were all dry I was able to describe the darker, finer branches and tree trunks using Payne's Grey acrylic ink, the oil pastel breaking up these marks to indicate snow on the trees. The last touches were the stalks in the very near foreground, painted in with white and a little Payne's Grey acrylic ink.

Winter River and Early Sunshine

28 × 40cm (11 × 15¾in)

Acrylic paint, oil pastel and ink on acrylic paper

This stretch of river near my home offers stimulating scenes throughout the year. Here I chose a low viewpoint, with the horizon of trees just catching the first rays of an early morning sun and a narrow strip of sky. Most of the composition is taken up by the river and foreground frosty grasses and the structural element of the trees on either side of the river. The colours are not quite complementary, but the warm orange-yellow of Cadmium Yellow Deep in the distant trees and the reflections is placed against the rest of the painting, executed in a palette of Dioxazine Violet, Prussian Blue added to Titanium White and small amounts of Quinacridone Magenta. This near-complementary palette of colours adds a pleasing colour dynamic to the work. I added flashes of pale magenta oil pastel here and there to prevent the painting from becoming too cold in hue. The branches and trunks of the trees were described using Burnt Umber acrylic ink applied with the sharp edge of the painting knife.

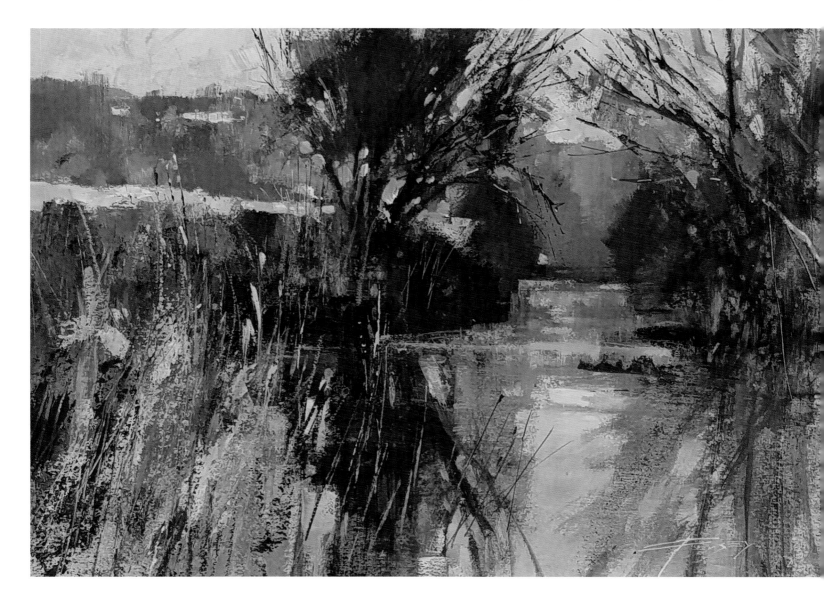

Spring

As the first stirrings of the new season appear, the landscape takes on a new cloak. The slow emerging of a green vale, fresh in colour, sharp and new, can add a very inspiring hue to the skeletal appearance of a winter landscape. A mist of green begins to form over the trees and spring flowers start into growth; perfect to make your spring paintings come alive with nature's rebirth.

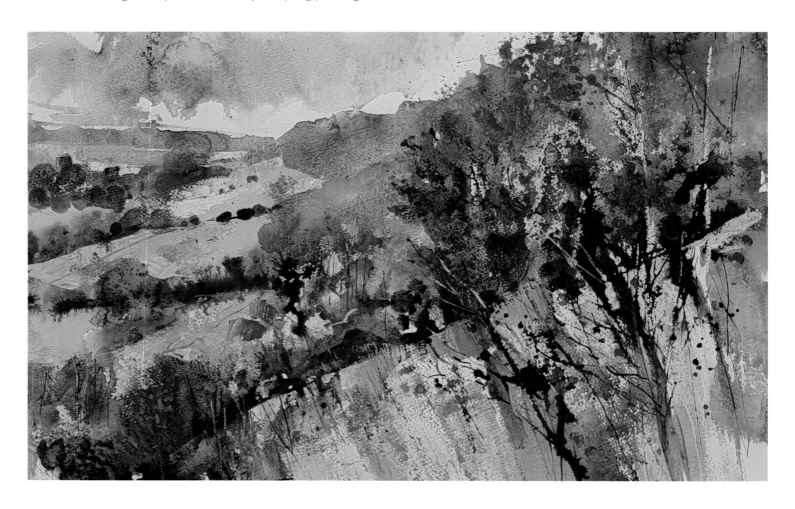

Down into the Valley
36 × 52cm (14¼ × 20½in)
Watercolour, acrylic paint, ink and oil pastel on Not watercolour paper

This valley view has all the signs of spring. The distant fields are rendered in a bright lemon yellow and the greens are sharp and a little acid. Although the trees are in leaf, their structure is still apparent. To heighten contrast in the landscape I used a strong Purple Lake acrylic ink to describe shadows, hedges

and trees and also the spiky foreground bush, still with its remaining red berries on show; the red adds a splash of complementary colour to the palette of green hues. The big clue to the season is the weather; clouds moving across the landscape, not a hint of blue in sight, and possibly a shower on the way!

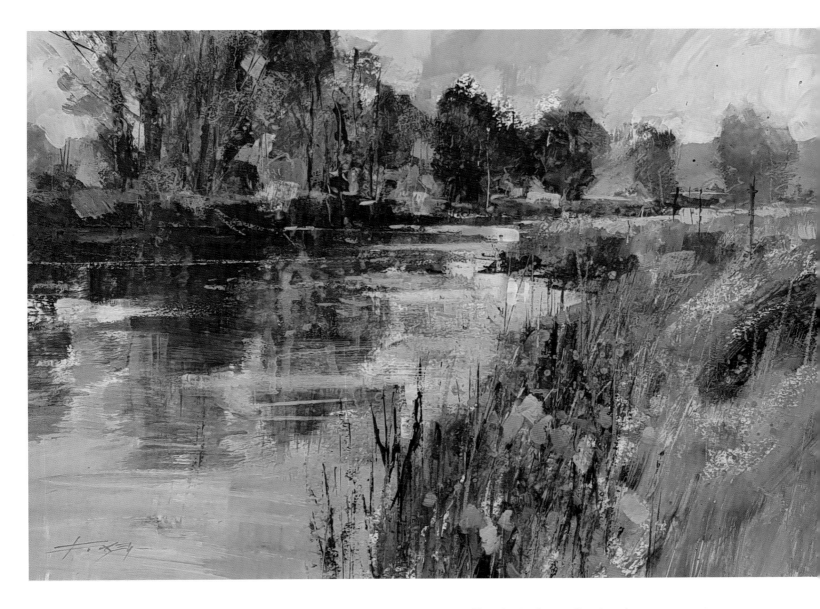

Spring by the River

34 × 47cm (13¼in × 18½in)

Acrylic paint and ink on acrylic paper

The advance of spring can be seen clearly in the trees on the opposite bank of the river, still showing their bare winter structure but with a haze of soft green on the brown branches. I added some spring flowers to the foreground to enhance this seasonal flavour, but still retained a few seedheads and bare stalks. The small touch of Phthalo Blue mixed with white acrylic showing through the clouds and reflected in the still waters of the slow-flowing river also gives a promise of the summer season to come.

Summer

The greens of spring have now transformed into a richer and deeper hue and tree canopies cloak the underlying structure of trunks and branches. Your colour palette will need a rethink; introduce more blues, purples, lilacs and pinks and make colours brighter and more saturated. These changes will endow your paintings with brightness and impact.

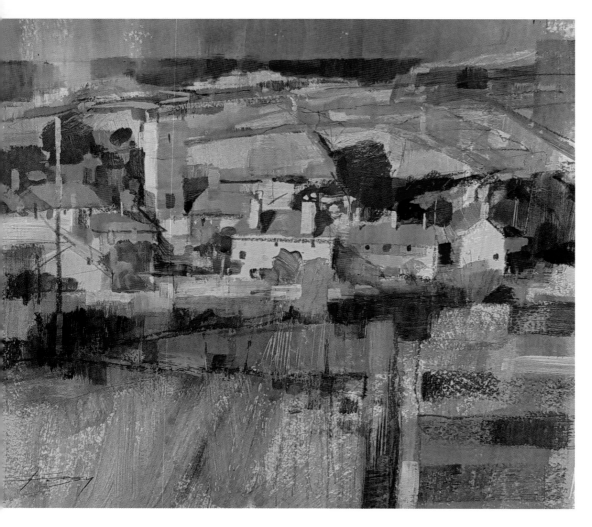

The Sunlit Village

32 × 35cm (12½ × 13¾in)

*Acrylic paint and oil pastel
on acrylic paper*

A high-summer palette of colours was needed for this little painting as the strong August sunlight made the entire landscape glow with colour and light. I underpainted the whole of the land area with Lemon Yellow then proceeded to loosely outline the building shapes with purple oil pastel. Next I blocked in simplified descriptions of roofs and trees – my aim was to keep the painting rather flat, with a lack of aerial perspective, and to exaggerate fields, buildings and trees in simplified shapes. The use of complementary colours Lemon Yellow and Dioxazine Violet conveys sunlight and shade, and with Cobalt Blue for the sky and mixed with Lemon Yellow for the trees, I think I captured the sunlight I was aiming for.

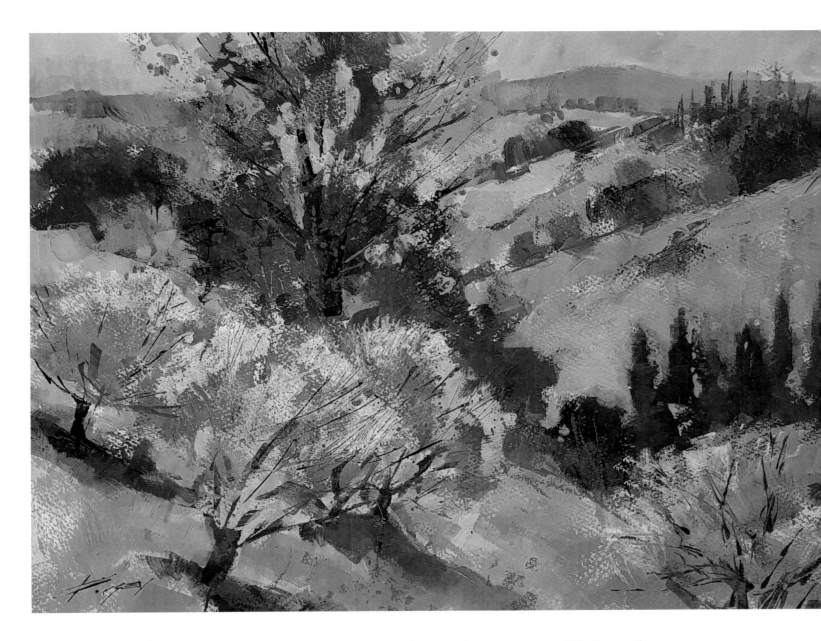

Summer in the Tuscan Hills

33 × 43cm (13 × 17in)

Acrylic paint, ink and oil pastel on Not watercolour paper

For this glorious summer day in Tuscany I was able to bring out bright fresh greens and vivid pinks. I chose a palette of Light Olive Green (one of the few ready-made greens that I use), Cobalt Blue, Quinacridrone Magenta and Lemon Yellow acrylic paint, Violet acrylic ink and bright pink oil pastel. I started the structure of the trees using Violet ink and then laid greens on top in paint, allowing the ink to show through in places and retaining it for the darker shadows. The Cobalt Blue, with a little white added, was perfect for the sunlit hills in the far distance and a middle-distance group of trees. The addition of the pink pastel was a bit of a gamble, but once I had dashed in a few marks I was quite pleased with its brash colour as it added an intense colour contrast to the overall green of the painting. The blossom on the foreground trees was a combination of very pale green and then a smear of white pastel over the top, allowing the underpainting of the green/grey of the tree to show through.

Autumn

The dramatic change that comes over the landscape in autumn is always inspiring. Greens have begun to take on a more golden cast. Ochres, sienna, orange-reds and russets now need to be considered for inclusion in your palette, alongside the complementary blues and purples. The skeletal shapes of the trees start to emerge again as they shed their leaves, producing a lot more incidental colour on the ground – a very useful addition to the colour content of the painting.

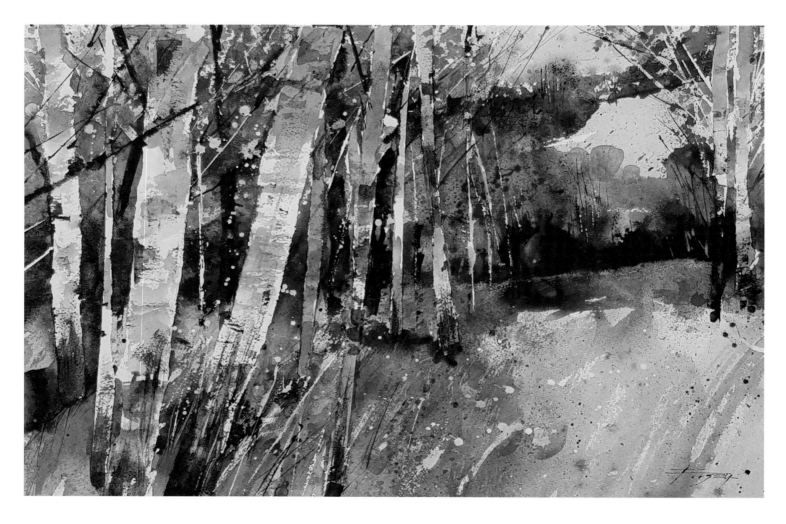

Through the Birch Trees
24 × 34cm (9½ × 13¼in)
Watercolour and acrylic ink
on Not watercolour paper

The silver birch trees standing like glowing white sentinels in this autumn landscape make a strong contrast in shape and colour with the trees in the distance. This painting is basically just three colours: Lemon Yellow, Quinacridone Gold and Payne's Grey watercolour, plus some Burnt Umber ink. The hint of quiet green was produced more or less by accident, as the three colours washed together to create a mere touch of a very useful green.

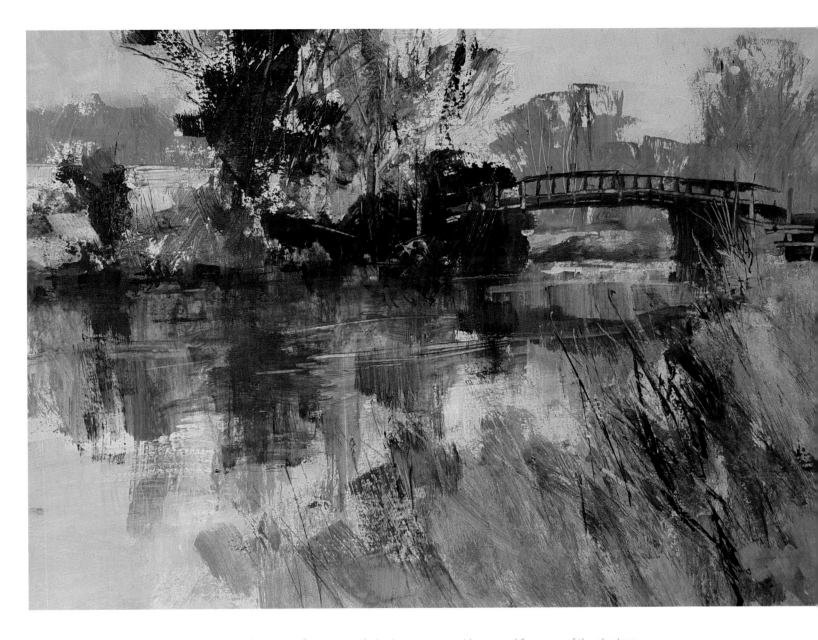

Bridge over the River

32 × 48cm (12½ × 19in)

Acrylic paint, ink and pastel

on acrylic paper

The onset of autumn entirely changes the hues of the landscape. For the main carriers of this scene of a footbridge over the river I chose my favourite pairing of colours, Dioxazine Violet and Quinacridrone Gold, with some small additions of pale green and a touch of pale Lemon Yellow and Cadmium Orange. The mixture of the Gold and Violet paint created a very dark rich brown that I have used for some of the shadows, while a little white added to it produced a pale brown for some of the trees behind the bridge. I have also included touches of this mix to the foreground grasses along with a little orange oil pastel in places, hinting at fallen autumn leaves, to add to the mood of the autumn season.

Changes in the weather

The weather influences the mood, light and colours of a landscape and its effects can be the main factor that inspires an artist to paint the scene in the first place. The surroundings of a walk or drive that is a regular part of your experience can be suddenly transformed from everyday ordinariness into the most magical landscape, enough to make you want to take your paints out immediately and capture the scene before the moment passes. Many artists have dedicated themselves to trying to depict these changes in weather; the drama and pure elemental qualities of the work of Turner, and the sublime qualities of sky, field and river captured in John Constable's paintings, are particularly worth studying in this respect.

A keen sense of observation and committing what you see to memory is a good place to start from in order to appreciate the effects of weather. Photographs and rapid sketches with a few jottings when you are out and about are a great help, while careful notes of the way the weather has affected the colours when you have more time to spare will be of considerable importance when you want to tackle ambitious paintings.

Fog and mist

The shrouding of the landscape by fog or mist can be very inspiring for the artist. A familiar place is transformed into a more mysterious environment, with shapes softened, light filtered and distance exaggerated by this veil of atmospheric vapour. I find it one of the most inspiring weather effects as its influence can transform a scene and create a magical, mood-filled painting.

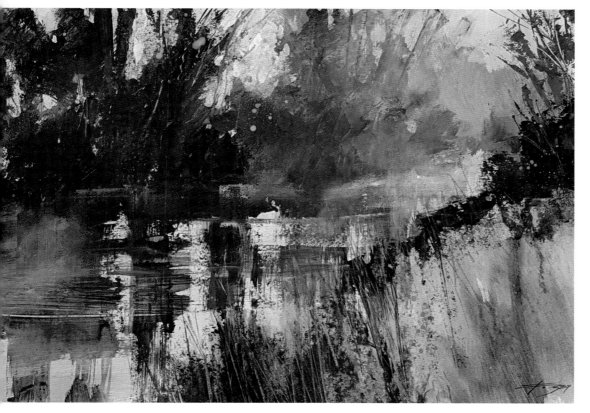

River Mist
30 × 46cm (12 × 18¼in)
Acrylic paint on acrylic paper

This painting was a response to an early morning walk by a river just as the sun was rising, with a morning mist on the water. It was a familiar location so I used little more than memory for it, and also a very limited palette of acrylic colours. I chose Indigo, Cadmium Orange and Titanium White acrylic paints, endeavouring to capture the colours of a river just after sunrise. I worked quickly, with just a flat 25mm (1in) brush, and made marks with a palette knife to describe branches and other small details in the scene.

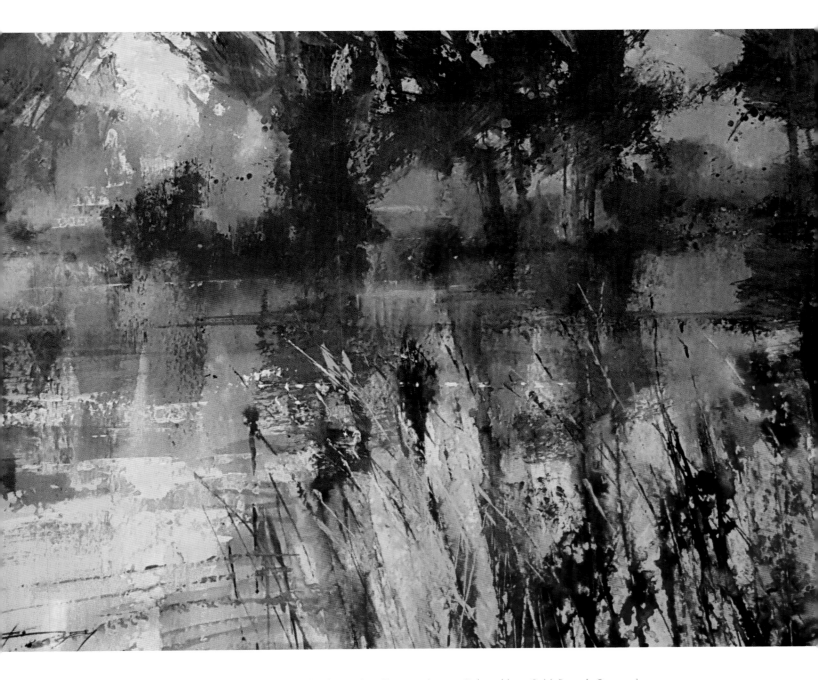

Autumn River

32 × 48cm (12½ ×19in)

Acrylic paint on acrylic paper

For this painting it was the silhouetted trees on the far bank and the golden reeds in the foreground that inspired me. The light was golden and I chose a simple palette of acrylic colours,

Quinacridone Gold, Payne's Grey and Titanium White, plus acrylic ink in Burnt Umber, to capture the scene. I painted a light Quinacridone Gold background to start, giving the painting a warm glow.

Rain

Rain can be very influential in transforming a coastal landscape into an elemental piece of visual theatre. The increased sense of distance and depth in paintings depicting views of open water is caused by the misty appearance rain bestows upon the scene, simplifying shapes and obscuring detail in headland and cliff. Rain is also a chance to include a faint diagonal wash across the scene, as if rain is sweeping across the bay.

Coastal Showers

31 × 39cm (12¼ × 15¼in)

Acrylic ink and acrylic paint
on acrylic paper

A rocky coastline with a passing powerful shower created the dynamic scene of diagonals and strong, dark shapes of rugged rocks and pouring rain.

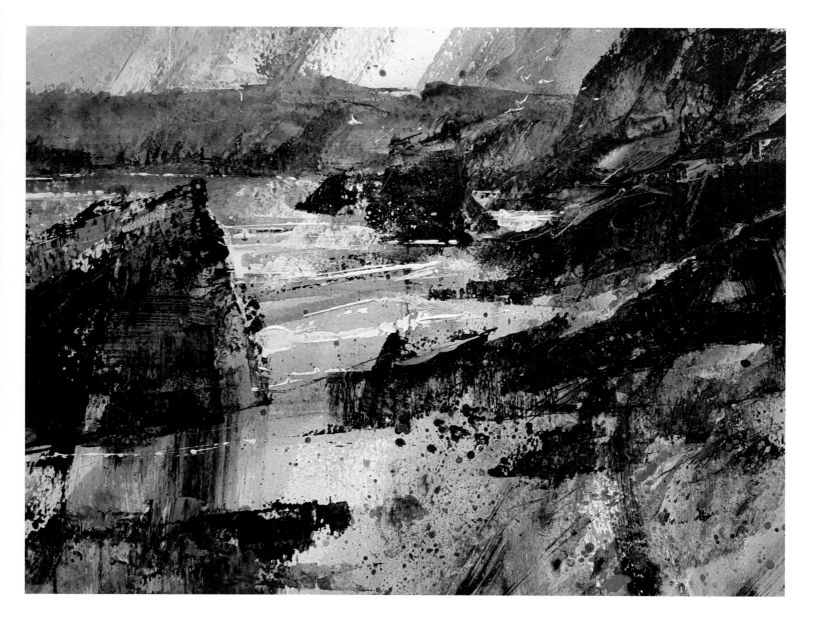

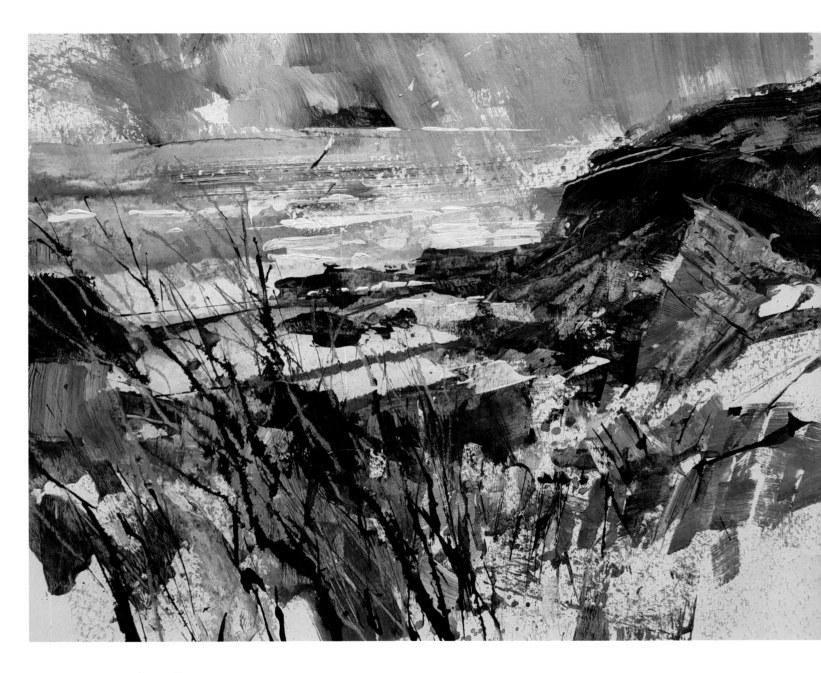

Stormy Coast

33 × 44cm (13 × 17¼in)

Acrylic paint, oil pastel and acrylic ink on acrylic paper

I used diagonal slashes of thin acrylic paint to obscure the
horizon behind a veil of rain, dark silhouettes of twig and branch
and an old wall to give an energetic dynamic to the painting.

Snow

Of all types of weather conditions, snow obviously has the most influence on the appearance of the landscape. It can transform the most mundane scenes into dramatic, almost monochrome visual experiences that can be very inspiring. The colours of the light are altered enormously with shadows containing blues, purples, pinks and yellows, encouraging the artist to try a very different combination of colours.

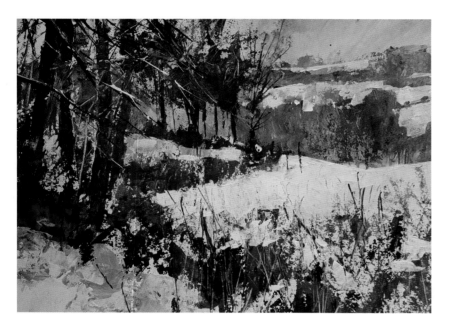

Walk to the Woods

26 × 35½cm (10 × 14in)

Acrylic paint, acrylic ink and oil pastel on acrylic paper

A familiar walk along the lane became magically altered by a heavy snowfall. I used Cadmium Orange and Payne's Grey acrylic and Titanium White, with the addition of Orange oil pastel to enhance the foreground colour and provide some texture to the hedge and tree. This increased the depth of the painting, with its warm foreground and cool background.

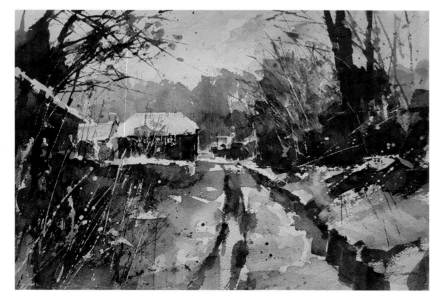

Snowy Track

35 × 52cm (13¾ × 20½in)

Watercolour and acrylic ink on Not watercolour paper

This is a familiar scene on a local walk that was transformed by a quite heavy snowfall, inspiring a painting that could exploit the strong tonal and colour contrasts that the snow has brought to the view. I used the deep ruts of the farm track to lead the eye into the scene and towards the old farm buildings, and chose watercolours in Prussian Blue, Alizarin Crimson and Raw Sienna, along with Burnt Umber acrylic ink for the darker foreground areas. Small touches of masking fluid were also used to describe frost and snow on the branches, applied with a palette knife, a bamboo pen and spatter, allowing it to dry completely before I applied any washes.

Frost and ice

Visually, a heavy hoar frost can almost be more beautiful than snow, covering every twig and blade of grass in a glittering coat of white. A certain amount of the undersurface can also show through the white layer, giving the grass a very pale turquoise blue colour with shadows a darker blue-green. Frost offers a lot of artistic possibilities and can present the opportunity to concentrate on the sculptural appearance of stalks and seedheads. As it has a tendency to disappear quickly, I recommend going out first thing in the morning, which is especially rewarding if the clear sky allows early sunshine to illuminate the landscape and add even more sparkle to the scene.

Frosted Riverside
50 × 60cm (19¾ × 23½in)
Acrylic paint and acrylic ink on canvas

My attention was initially captured by the sculptural shapes of the frosted stalks and umbellifers that created a strong foreground focus. The sun was just rising and the distant trees were bathed in a warm, golden light, in great contrast to the cool blues of the foreground. I chose Yellow Ochre, Raw Umber, Golden Ochre and Titanium White acrylic paints, plus acrylic inks in white and Burnt Umber. I worked with a flat 38mm (1½in) brush to make broad, expressive marks, keeping the shapes simple in contrast with the more delicate description of the foreground stalks.

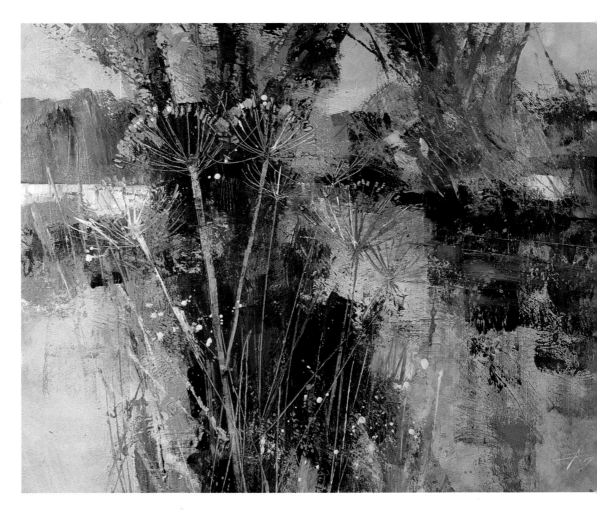

Sunshine

While it may be the most comfortable weather in which to paint the landscape, bright sunlight can provide challenges to the artist when it comes to colour choices that will render a satisfactory feeling of warmth and sunlight, shadows and distance. Colours may be a little exaggerated to express the intensity of the sunlit scene. For the hues found in shadows, choose a selection of more intense colours composed of mixtures of primaries and secondaries, overlaid or juxtaposed to create shimmering and interesting areas that complement the brightly lit elements of the scene. The great landscape works of the Impressionist and Post-Impressionist painters reveal an exciting and extraordinary use of colour in their sun-filled landscapes.

Italian Summer
28 × 39cm (11 × 15¼in)
*Acrylic, oil pastel and acrylic ink
on acrylic paper*

A summer view across a vineyard into a valley in the Italian countryside, using greens, magentas and violet to create strong colour contrasts.

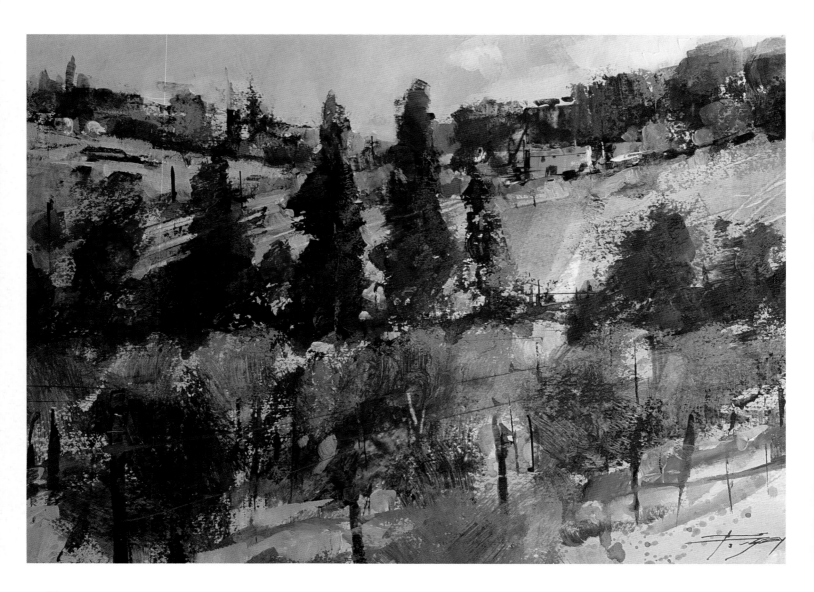

Chalky Road
30 × 40cm (12 × 15¾in)
Watercolour and oil pastel
on Not watercolour paper

Down the lane and across the fields, the strong early morning sunshine created shadows on the white road, with colour contrasts of yellows, greens and violets.

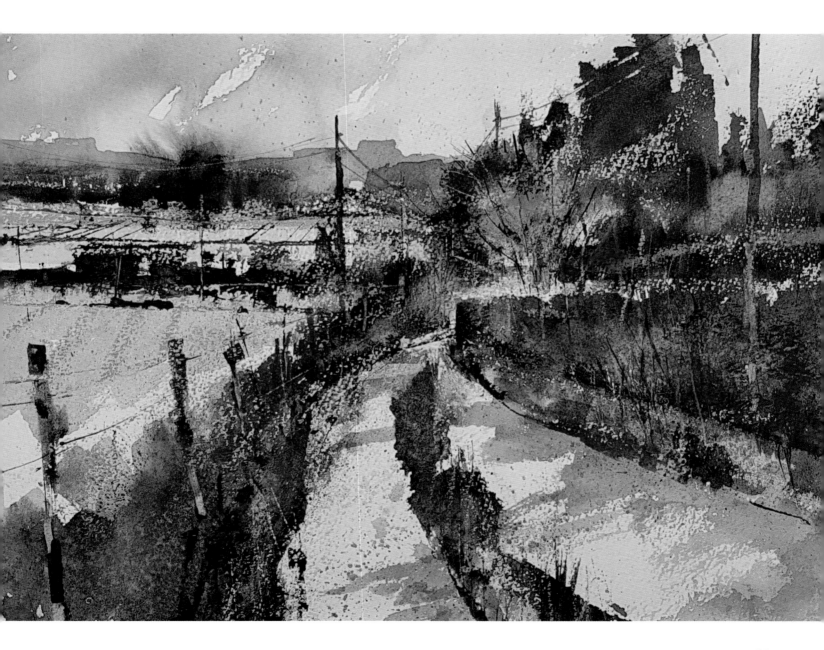

MIXING THE MEDIUMS

Choosing the painting mediums that are going to be mixed together needs a bit of thought before you set off on the work. It is worth considering whether your intended painting naturally suits a certain combination of media and techniques, or would you prefer to go on an adventure? Both approaches can work, but the former will probably yield a more pleasing result. Familiarizing yourself with the character of your chosen media is a good idea; for instance, perhaps a lot of texture is required, so oil pastel would be a good starting point for either a watercolour or an acrylic painting.

Watercolour and acrylic ink

This combination can be one of the most expressive and unpredictable, but it is sometimes worth playing to its strengths and allowing the ink to mix with the watercolour, then celebrating the unexpected outcome; some marvellous things can happen. The ink is also good for applying a little detail in the final parts of the painting to give crisp, graphic results.

Autumn Birch Trees

24 × 34cm (9½ × 13¼in)

Watercolour and ink on Not watercolour paper

I was inspired to paint this group of birches I saw on an autumn walk, the white of the trunks beautifully upright and glowing in the sunshine, the golds and russets of the foliage behind them creating a semi-abstract set of shapes. The loose washes of watercolour for the foliage are enhanced with scattered, freely applied blobs and splatters to imply shadows and depth. The white trunks of the trees are left mostly as blank paper, darkened in places to create shadows and form, with darker dry-brush marks to describe the scars and textures of the bark.

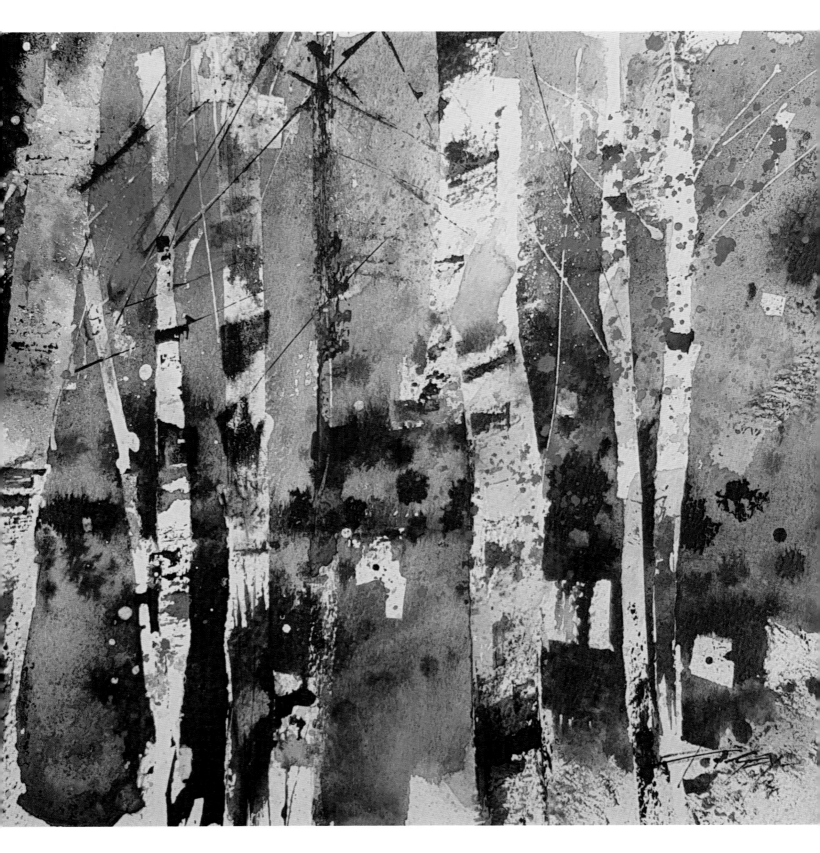

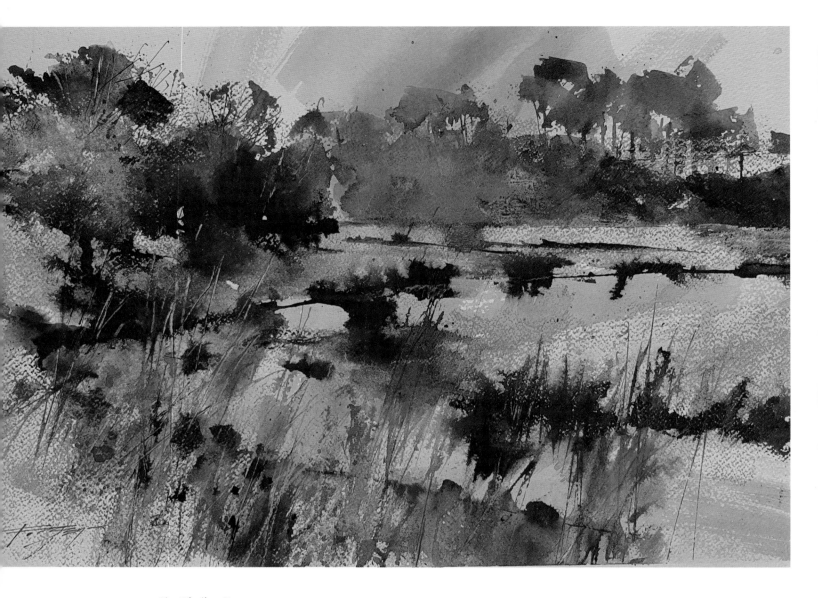

The Winding Stream

30 × 40cm (12 × 15¾in)

Watercolour and ink on Not watercolour paper

I sketched this scene from my car as the August weather was wet and windy. I liked
the way the stream curved into the scene, lazily meandering through grass and reeds.
An energetic wash of Payne's Grey was followed by Lemon Yellow and Raw Umber
watercolour to describe the bark and trees. Antelope Brown acrylic ink was blobbed,
dry-brushed and smeared into the banks and trees to create a small group of trees,
reedy riverbanks and foreground grasses. Finally, I added droplets of Cadmium Orange
ink to enhance the foreground and roughly describe seedheads and grasses.

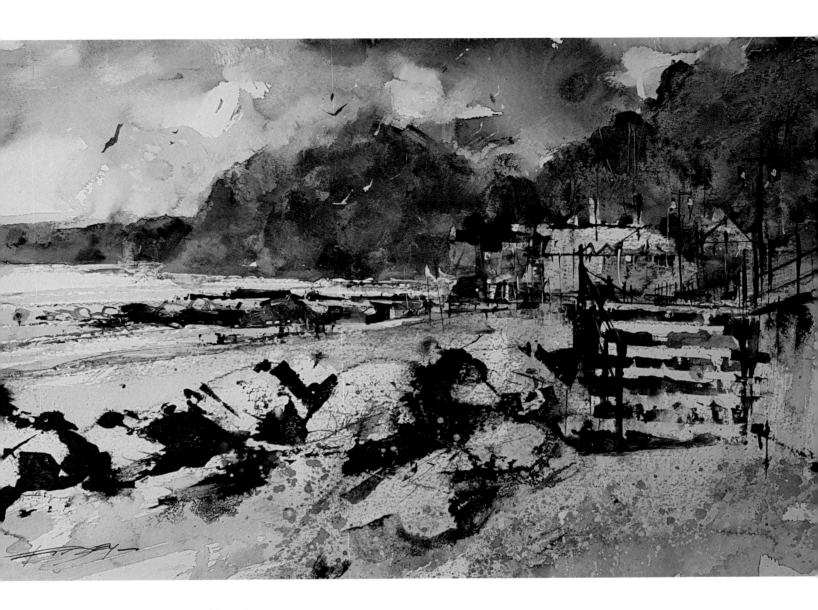

Showery Day, Sidmouth

35 × 50cm (13¾ × 19¾in)

Watercolour and ink on Not watercolour paper

I selected very few colours to paint this scene of the beach below cloud-topped cliffs
in this seaside town in Devon: Payne's Grey, Cadmium Orange and Burnt Umber ink and
Payne's Grey watercolour. Touches of white detail, including the seagulls, were created
using white ink. The simple rendition of the distant buildings, steps and foreground
boulders is enhanced by the dark, dramatic washes of the background cliffs. I used
plenty of dry brushwork and splattering to create sand, pebbles and foamy waves.

Along the Beach, Tregardock

The coast can provide never-ending subjects to inspire the artist. This rocky beach provides the perfect opportunity to work very loosely, quickly and expressively to capture the sheer energy unleashed by the power of wave, wind and weather. The light can have a special quality by the coast, the sparkle of sunlight bouncing off the surface of water and wet rocks, creating a dazzling sunlit vista. In different weather, and at another time of day, the scene will be completely different and offer the artist yet more opportunities to express this landscape in a fresh palette of colours and marks.

A limited palette of carefully chosen colours – Cobalt Blue, Cerulean Blue, Quinacridone Magenta, Quinacridone Gold watercolours and Payne's Grey acrylic ink – provides harmony. Most of the drama in this painting comes from the wide range of tones, with the light coming from directly above and in front of the viewer.

MATERIALS

Watercolour
Cobalt Blue
Cerulean Blue
Quinacridone Magenta
Quinacridone Gold

Acrylic ink
Payne's Grey

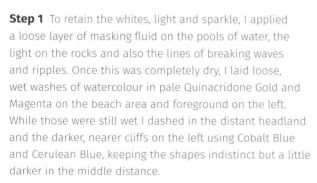

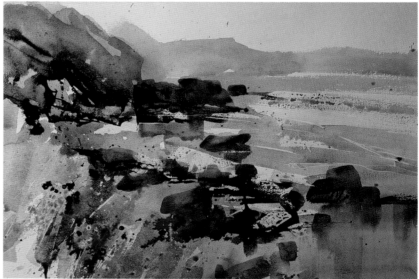

Step 1 To retain the whites, light and sparkle, I applied a loose layer of masking fluid on the pools of water, the light on the rocks and also the lines of breaking waves and ripples. Once this was completely dry, I laid loose, wet washes of watercolour in pale Quinacridone Gold and Magenta on the beach area and foreground on the left. While those were still wet I dashed in the distant headland and the darker, nearer cliffs on the left using Cobalt Blue and Cerulean Blue, keeping the shapes indistinct but a little darker in the middle distance.

Step 2 While the initial washes were still damp, I added a darker mix of Gold and a touch of Magenta to the foreground and the top of the cliffs, then a warm wash of the same colour to indicate the grassy clifftop. As this started to dry I began to describe the boulders and large rocky stacks in the middle distance. I used a mix of Cobalt Blue and Magenta watercolour to create a warm violet-grey and, using a flat brush and palette knife, indicated the craggy shapes with smears. I added lines and blocks of tone using the Payne's Grey ink, applied with the dropper on the bottle, knife and fingernail, letting paint and ink run together to create unpredictable shapes of colour and texture.

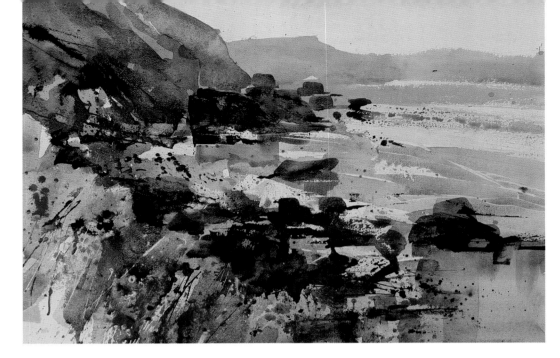

Step 3 I continued to draw and spatter and drag the paint across the paper, creating the appearance of cracks, and made small marks to describe in just a little more detail the foreground. I also used the same technique to indicate blowing grasses and seedheads on the foreground cliff edge.

Step 4 When all the paint on land and sea was dry I quickly dashed in the sky using a pale grey-violet mix and light washes of the two blues onto a dampened sky area. After a patient wait I removed the masking fluid from the entire surface of the paper, revealing the whites of waves, the gleam and sparkle on the rocks and the lighter wispy foreground grasses, adding a little Quinacridone Gold to some of these to tone down their whiteness. Then, using a dip pen and the point of the palette knife, I indicated a few seagulls to add a touch of life and movement to the scene and a few more spatters and marks to the sea and waves. The danger here is to add too much – it is often better to let the viewer's eye fill in the missing detail.

Along the Beach, Tregardock

36 × 53cm (14¼ × 20¾in)

Watercolour and ink on Not

watercolour paper

Watercolour and oil pastel

I particularly enjoy using this combination of media for a quickly executed landscape, often onsite as only a small selection of equipment is required. The oil pastel is laid down first to act as a resist to the watercolour, particularly in foreground areas where strong shapes can be retained, such as flowers, twigs, grasses and so on. It is also useful as an effective addition to areas of water – rivers, lakes, the sea – to add sparkle and movement.

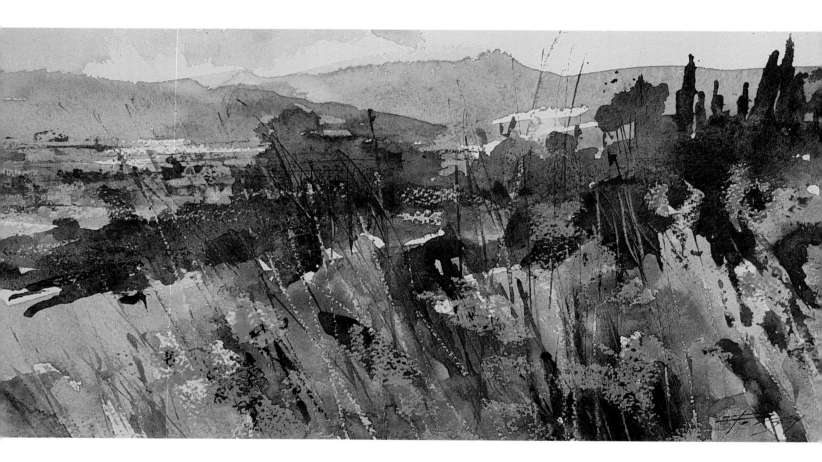

Tuscan Hills
20 × 40cm (8 × 15¾in)
Watercolour and oil pastel
on Not watercolour paper

This very quick watercolour and pastel was executed directly after a morning walk when the colour and light I had seen were still fresh in my mind. I dashed in bright Light Cobalt and Lemon Yellow oil pastel to create cornflowers and grasses in the foreground and an indication of bright, sunlit fields in the valley. Next, I used pale washes of Cobalt Blue and Lemon Yellow paint to describe distant hills and darker mixes to create the middle-distance tree line, with Dioxazine Violet watercolour dropped in as the washes dried to add extra depth and colour interest.

Beside the Lake

26 × 35½cm (10 × 14in)

Watercolour and oil pastel on Not watercolour paper

Inspired by an early morning walk beside a Swedish lake,
I made a quick sketch as the morning sun sparkled on the still
water. I began with Yellow Ochre pastel on the bankside grasses
and the sunlit branches and tree trunks, and white oil pastel
on the water. I then used three colours, mostly Yellow Ochre
and Prussian Blue, which I washed in to create the riverbank
and the water reflecting the blue sky above, with a very small
amount of Dioxazine Violet in the tree shadows. As I added the
blue wash to the water, the sparkle of white oil pastel revealed
itself. I used stronger colour to create the shadows and darker
trees in the middle distance.

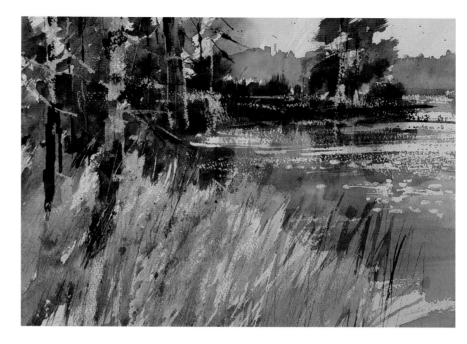

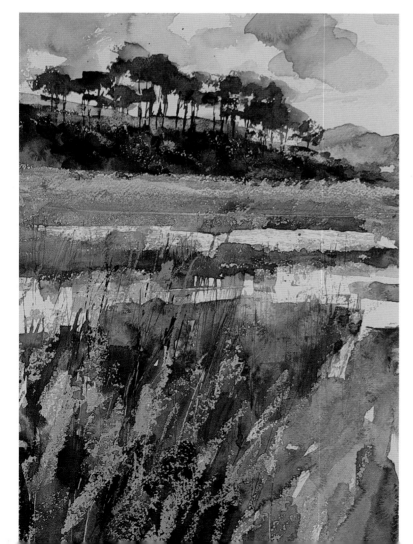

Reedbeds and Tree Line

34 × 24cm (13¼ × 9½in)

Watercolour and oil pastel on Not watercolour paper

My inspiration began with the line of pine trees along the ridge
of land rising from the reedbeds and watercourse, the vertical
silhouettes of trees against a pale sky counterbalanced by
the horizontal lines of the reflective water and reeds. I started
with a Cadmium Yellow oil pastel for the foreground reeds and
plants and, using light strokes, for the grassy flatland below the
shadow of the ridge. I used Payne's Grey paint for the pine trees
and touches of Lemon Yellow and Raw Sienna for the reeds,
leaving the white of the paper for the streams and wetland.
To finish, I quickly washed in darker mixes of the colours for the
foreground shadows, the pastel marks resisting the washes.

The Winter River

This painting of bare trees beside a river, the banks covered in a frosty blanket, is based on a very speedy sketch made on a wintry morning in December. The banks were covered in a layer of hoar frost and as the sun rose, it lit the bare, skeletal shapes of the branches of the trees by the river. I had to rely quite a lot on memory for this as the sub-zero temperatures were not conducive to lingering with exposed fingers clutching a pencil or brush. My choice of palette is based heavily on the colour contrast of the complementary colours orange and blue, the mix of the two giving me a useful dark brown for shadows and deep, dark reflections in the river.

MATERIALS

Oil pastels

Yellow Ochre

Turquoise Blue

Titanium White

Watercolour

Cadmium Orange

Cobalt Blue

Tools

Flat 25mm (1in) brush

Step 1 My first marks in this painting were made using white and Yellow Ochre oil pastel. I applied the latter mainly to the upper parts of the painting to act as a resist to the watercolour, making marks to represent the branches and trunks caught in the early morning winter sun. Next I applied the turquoise pastel broadly to the foreground to depict colour in the frosty grass and added white to describe the stalks and grasses on the riverbank. These would retain their striking whiteness when washes were painted in.

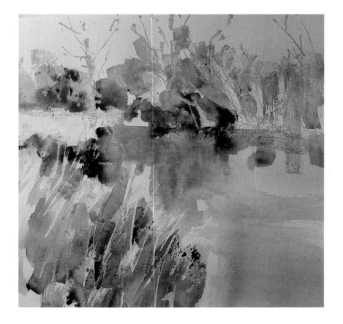

Step 2 Next I painted Cadmium Orange watercolour over the top of the paper to represent the branches and remaining leaves caught by the light of the sun as it rose. While this was still wet I painted in the Cobalt Blue in the foreground and dropped in some blobs of orange to darken and neutralize the rawness of the blue.

I applied a pale blue wash to the river, mostly in the foreground and leaving some white as reflections of light. I added a mixture of the two colours to the river beneath the trees to depict the reflections in the icy water, allowing the colour to drift and mix unaided. Also I added to the sky area to keep this scene wintery.

Step 3 I felt the reflections needed to be a lot darker, so I used a mix of the orange and blue to increase the strength of the wash and create a very clear distinction at the edge of the bank and the river, carefully painting the dark reflection up to the edge of the frosty grass on the bank.

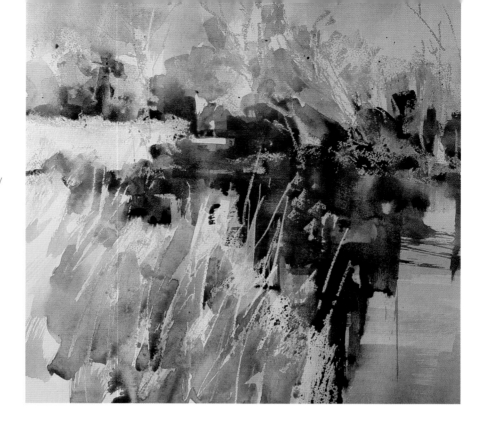

Step 4 Next I added some very strong darks to clearly define the shape of the trees and emphasize the sunlit trunks and branches. The hint of trees in the distance was also enhanced with some dabs and blobs to give the impression of trees even further away. I then added branches to the trees in this darker paint using a stick, fingernail and palette knife, completing the naked nature of the winter trees. Lastly I lifted out a small area of the dark river reflection to create a sense of a moving surface.

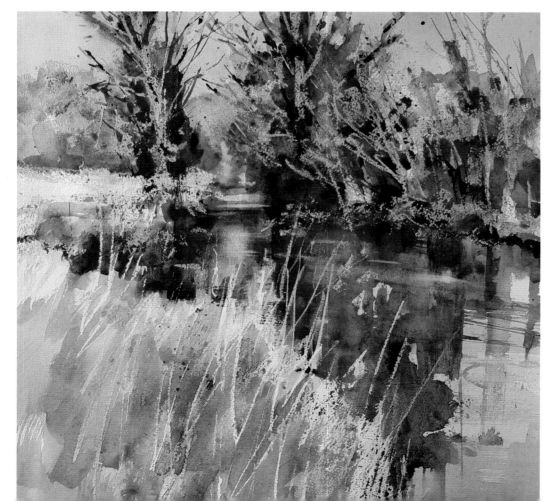

The Winter River
35 x 35cm (14 × 14in)
Watercolour and oil pastel
on Not watercolour paper

Watercolour and water-soluble crayon

Water-soluble crayon and watercolour make a good combination for quick location work as well as studio-finished paintings. I very often begin the work with crayon, dashing in the main shapes using a black, blue or brown water-soluble crayon, and when watercolour is added the crayon breaks up a little to represent tone, shadow, and texture as it drifts into the wet wash of colour.

Along the Riverbank

30 × 40cm (12 × 15¾in)

Watercolour and water-soluble crayon on Not watercolour paper

This painting was completed very quickly after returning from the riverside location with an even quicker sketch and the scene fresh in my mind! I used Prussian Blue and New Gamboge watercolour, Burnt Umber acrylic ink and a black water-soluble crayon to loosely sketch in hints of foreground shadow on rocks and branches.

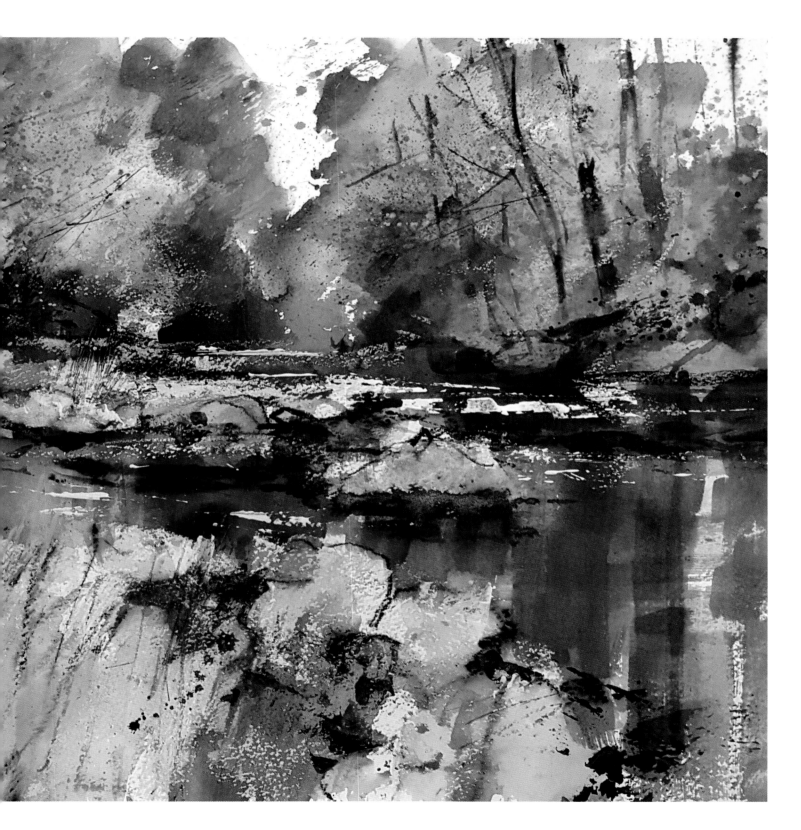

Cliff Walk

For this painting I chose a combination of materials that I find marvellous for working in a spontaneous, expressive way that has an element of linear drawing, adding another form of language to the painting. This creates a sketch-like quality and makes it an ideal method for painting on location, where taking too much in the way of heavy equipment can somewhat spoil the enjoyment of the event. In this painting I endeavoured to capture the breezy weather, fast-moving clouds and lively surface of the sea, the sun almost directly overhead. The scene has large areas of shadowy cliff counterbalanced with top-lit fields and foreground and the track leading your eye into the landscape, a visual as well as a literal pathway into the scene. I used two pairs of complementary colours to create an exciting visual combination.

MATERIALS

Watercolours
Cadmium Orange
Cobalt Blue
Dioxazine Violet
Lemon Yellow

Water-soluble crayons
Black
Ultramarine Blue

Step 1 The first step was to lay down a loose wash of Lemon Yellow watercolour. I began with the clifftops then made the foreground area just a little darker to bring it closer to the viewer. Into this Lemon Yellow, I dropped a little Cadmium Orange watercolour to warm up the foreground. As this initial wash dried, I painted the sea and sky in a very quick, open style, allowing a lot of white paper to be retained. The speed of application of these washes contributes to the appearance of movement in the water surface, the dry brush marks conveying texture too.

Step 2 Finding the right moment to apply the crayon can be a little nerve-wracking, but the ideal time is when the wash is still wet so that some of the crayon, being water-soluble, will drift and blur into the wet areas, allowing soft areas and harder edges to develop. I ensured that these lines did not create an outline to shapes but described the character of cliff edges, rocks and rubble in the foreground. This could also be softened in the next washes of watercolour.

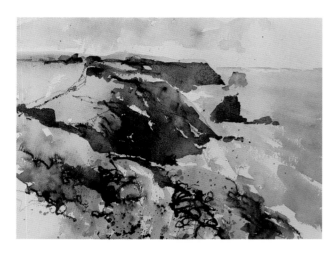

Step 3 After allowing the painting to dry I worked into the cliff areas. These deep, shadowy shapes still need to retain a lightness of touch rather than being too solid and opaque. I painted the far headland with a slightly bluer wash to accentuate distance and used a warmer purple wash for middle-distance shadows. I also used this purple on foreground shadows, with flicks, blobs and spattering added to create suggestions of outcrop and a broken wall on the right of the path. I also spattered and dripped more orange watercolour into this area, hinting at bracken, the warm granite colour and rust-coloured stone. While this was still quite wet, I enthusiastically drew into it with the crayons, using the blue one for the more distant fields and the black one to suggest foreground detail.

Step 4 Drawing into the washes is so enjoyable it can prove difficult to stop, but after adding suggestions of bushes and trees to the fields and using the upright in the far distance to suggest a building as a focal point, the painting was nearly complete. Lastly, I added a suggestion of a couple of fence posts on the right of the path and grasses to its left, plus a little cloud detail in the sky to accentuate the clouds and add to their sunlit quality.

Cliff Walk

30 × 40½ cm (12 × 16in)

Watercolour and water-soluble crayon on Not watercolour paper

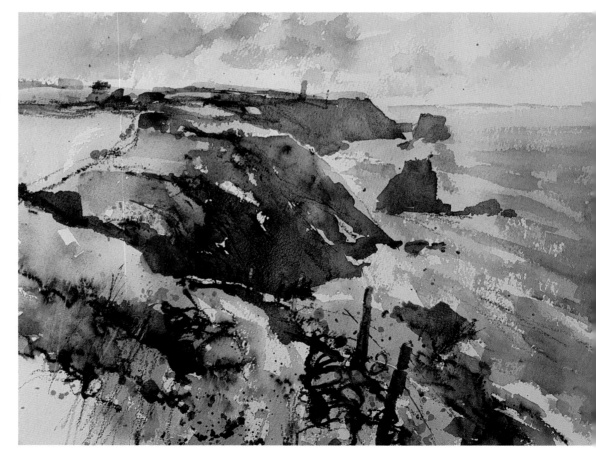

Watercolour, ink and oil pastel

Adding ink gives a strong graphic element to the work. I usually apply it later in the painting and often before the watercolour washes dry, allowing and encouraging the ink to spread, sometimes helped along with a spray of water, to create excellent textural, unpredictable effects. It is perfect for creating those 'happy accidents' in a painting.

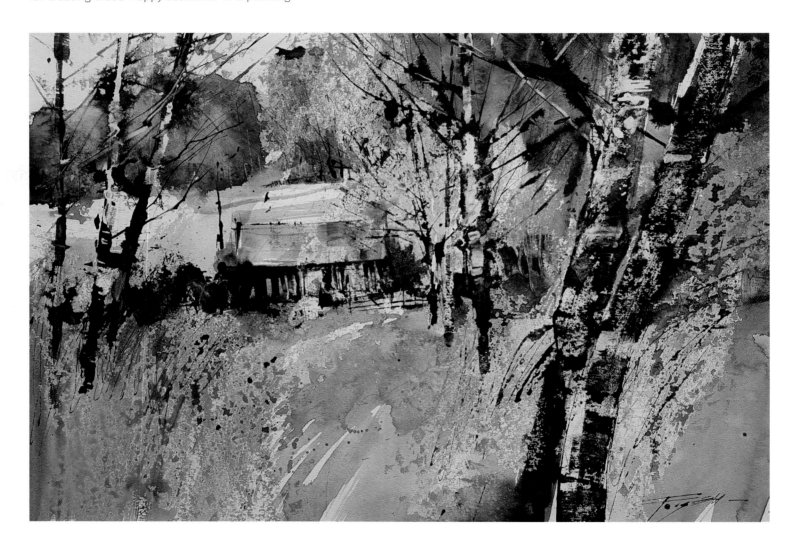

The Barn and Birch Trees
30 × 43cm (12 × 17in)
Watercolour, ink and oil pastel
on Not watercolour paper

The birch trees in their autumn colours and the isolated barn, acting as the focus of the scene, immediately appealed to me compositionally. I used oil pastel initially to act as a coloured resist to the watercolour, choosing Orange and Cadmium Yellow and also white to add texture and to retain the white of the tree bark. I then washed in Cadmium Yellow, Cadmium Orange and Payne's Grey watercolour. The birch trees were painted with Payne's Grey ink, using a palette knife and the edge of a piece of card.

Dark Trees and Golden Grasses
30 × 43cm (12 × 17in)
Watercolour, ink and oil pastel
on Not watercolour paper

The combination of watercolour, ink and pastel is perfect for this quickly executed painting. I used Yellow Ochre oil pastel to convey the light on the grasses and flashes of sunlight between the trees, and then Prussian Blue watercolour to indicate trees in the distance and the opposite riverbank. While this was still damp, I made indications of their canopies and the silhouette of the tree on the right using Payne's Grey. Lastly, I added a hint of some seedheads in the foreground.

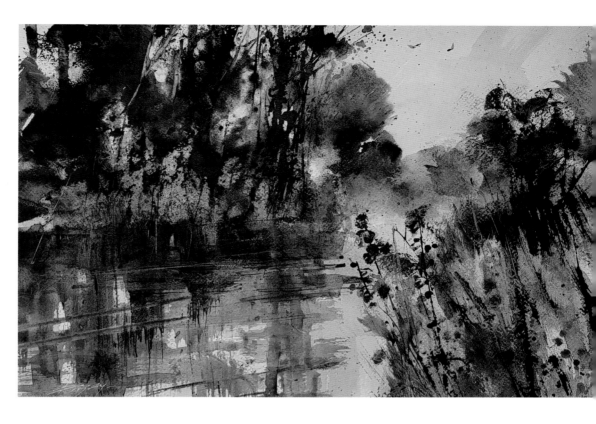

Reed Beds and Village
30 × 43cm (12 × 17in)
Watercolour, ink and oil pastel
on Not watercolour paper

One reason why I was inspired by the scene is that it suits my favourite composition – a T-shape, with the village running along the top of the T. I chose Cadmium Red and Cadmium Orange oil pastels, over which I laid similar colours in watercolour, plus Payne's Grey. The linear content was added using Payne's Grey acrylic ink with white paper retained for contrast and light on the sky, watercourse and sides of the buildings.

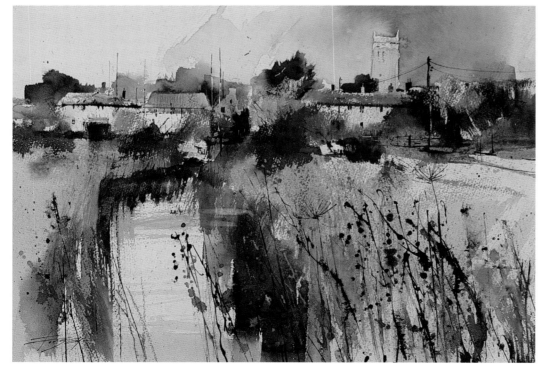

Prawle Headland

Prawle Point in South Devon has always been a favourite place of mine. It is isolated and has a lonely, timeless atmosphere that I love, whether I am painting it or just being there. The point itself has a soft shape dipping down into the sea, with green fields and a fine stone cliff arch at the end of it, adding to its very painterly silhouette. I chose to do this painting using three mediums that I always enjoy combining as they provide an unpredictable result. I chose a small palette of colours – Payne's Grey, Raw Umber and Quinacridone Gold watercolour, Antelope Brown acrylic ink, and white and Pale Ochre oil pastel. The support was Bockingford 140gsm (300lb) Not watercolour paper.

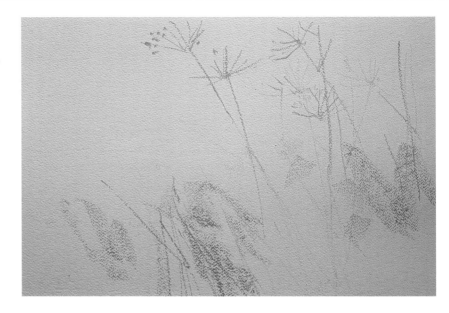

COLOURS

Watercolour
Payne's Grey
Raw Umber
Quinacridone Gold
Cobalt Blue

Acrylic ink
Antelope Brown

Oil pastels
Yellow Ochre
Titanium White

Step 1 Initially I used the Yellow Ochre pastel to describe some random foreground texture which would act as a resist to the watercolour washes I planned. I also described some of the tall, skeletal stalks and umbel heads of cow parsley growing next to the wall in the foreground. Next, I applied white oil pastel to the sea to break up the surface and suggest movement and waves.

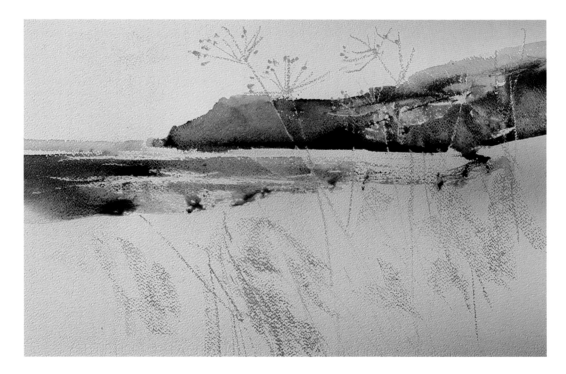

Step 2 Then I quickly laid loose washes into the sea, using Payne's Grey and Quinacridone Gold to create a fine, natural green. With a touch of Raw Umber I indicated cliff and rock behind the grasses.

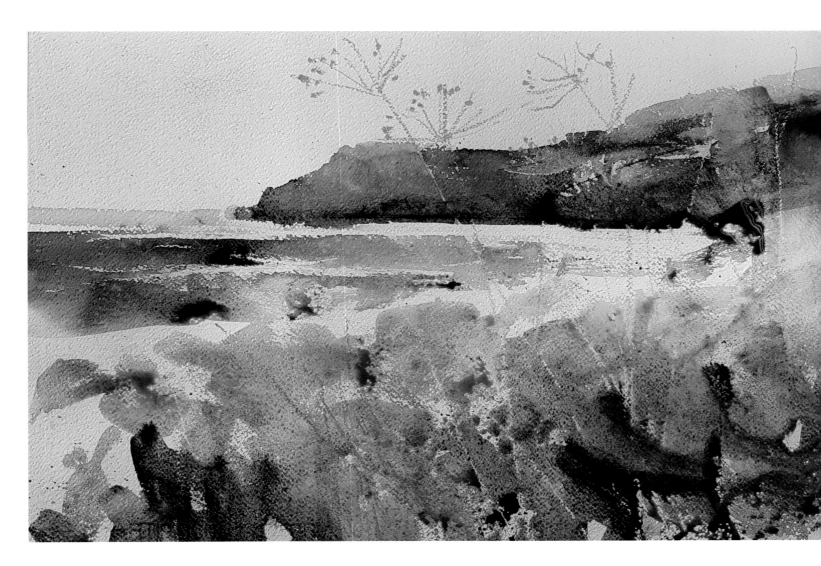

Step 3 The foreground colour was added in loose blocks of Quinacridone Gold and Raw Umber, allowing the colours to run together. While this was still wet, more Quinacridone Gold and some Payne's Grey were dropped into this area, the colours mixing together on the paper darkening the foreground in an unpredictable way and creating the illusion of shadow and depth.

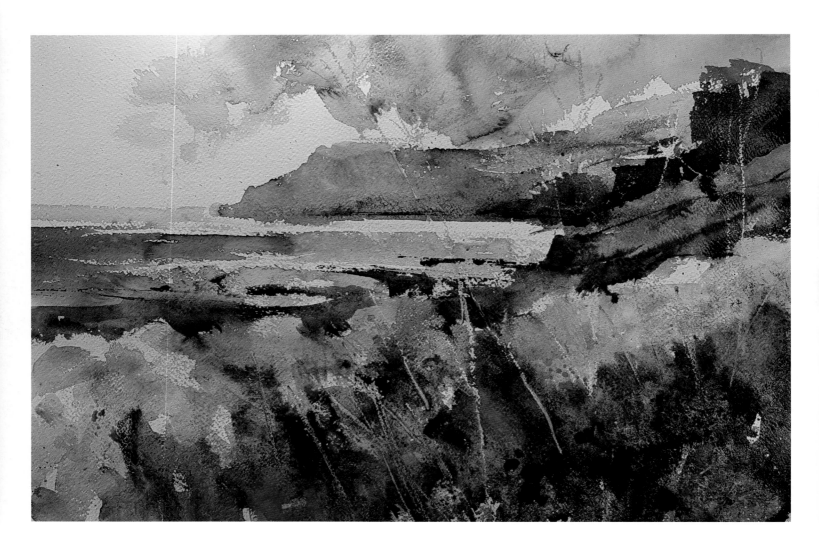

Step 4 Then came the moment to add the ink to the foreground, giving hints of stone walling and shadows between the rocks, and retaining a light hard edge along the top of the wall to act as a division between the foreground and scene beyond. The umbellifer shapes were retained by the earlier application of oil pastel drawing, acting as a resist. This was also the time to paint in the sky, using loose washes of Payne's Grey with just a little Cobalt Blue to describe a patch of clear blue sky. I also added the smallest amount of Cobalt Blue to the grey of the sea.

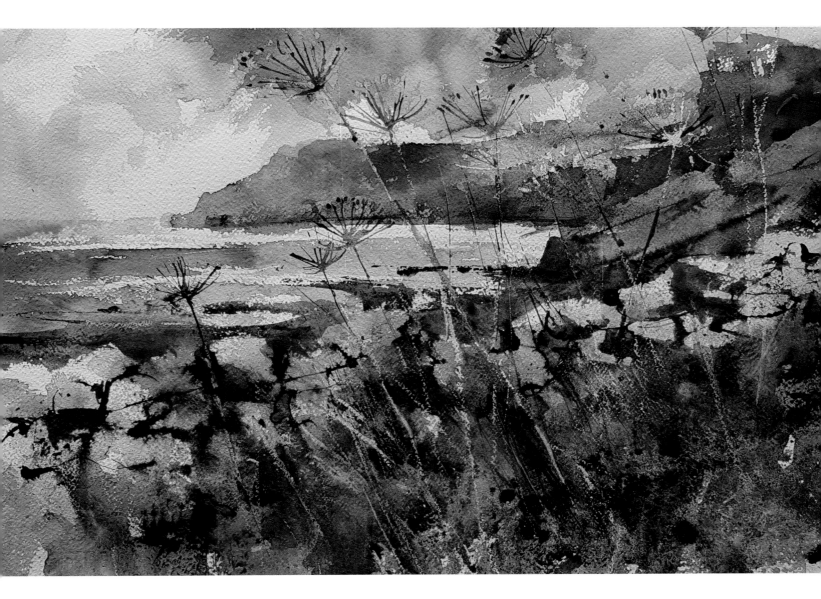

Step 5 In the final painting, the finishing touches have been added in ink to the umbellifer and foreground detail. Elements of counterchange help to distinguish the darks against the light sky and extra touches of light pastel were added to the grass and stalks in the foreground shadows. I took care not to add so much detail that the overall looseness of the work was lost.

Prawle Headland

30 × 40½cm (12 × 16in)

Watercolour, ink and oil pastel
on Not watercolour paper

Watercolour, water-soluble pastel and ink

A combination of these three media can produce excitement in its application, as its unpredictability is one of its most appealing features. Both ink and pastel are allowed to flow freely and mix on the surface, making it particularly good for scenes that are loose in structure and rely on the visual dynamic of the media to create impact.

DEMONSTRATION

The Tumbling River

A grey day in the mountains prompted this picture. Occasional glimpses of sunshine lit the scene but imagination and a dynamic choice of materials were called for to make the painting work. The water splashed over the green and grey rocks and I had to work quickly to do a sketch and grab some photograph references before it began to rain. My colours are based mostly on reality – the valley was grassy with ferns, now brown and russet in colour, and littered with fallen rocks and craggy outcrops, so I chose colours that I felt would capture the late autumn atmosphere of the scene.

MATERIALS

Watercolours **Acrylic ink**

Lemon Yellow Payne's Grey

Ultramarine Blue Orange

Burnt Sienna

Water-soluble pastel

Black

Burnt Sienna

Step 1 I started by drawing some basic shapes to describe the compositional elements – rocks in the foreground, and the far bank of the river – using black and brown water-soluble pastel. I wanted to keep the painting loose and sketchy, with a lot of white paper, expressive mark-making and dynamic passages of uncontrolled, splashy watercolour to add to the feeling of fast-flowing water and rugged natural landscape forms.

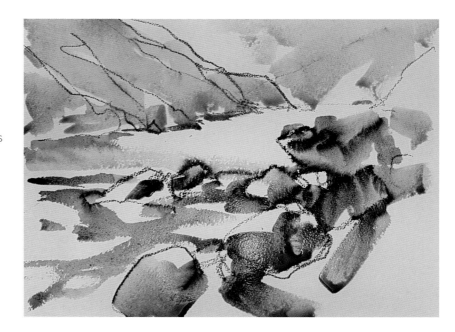

Step 2 Now came the exciting part. I dropped loose washes of Lemon Yellow and Ultramarine Blue watercolour into place, encouraging them to mix and break up the pastel drawing. I dashed in a wash of Ultramarine Blue to describe the sky and to cool the distant hillside. Next I added a few ripples into the foreground water, again letting paint and pastel dissolve together around the shapes of boulders.

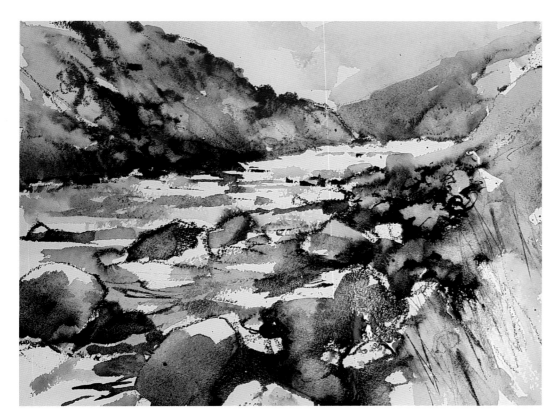

Step 3 Next I intensified the density and strength of the washes and added Lemon Yellow to both sides of the painting, allowing the watercolour and water-soluble pastel to meld together, and then added some Payne's Grey ink. I then added more pastel into the shadows and darks, mostly in the foreground and middle distance, to depict the rocks and ferns by the river.

The Tumbling River
24 × 34cm (9½ ×13¼in)
Watercolour, water-soluble pastel and
ink on Not watercolour paper

Step 4 I worked a little more in the way of darks into the foreground and middle ground of the painting to add to the tonal drama and interest. I also added another layer of aerial depth by including a hint of very distant hillside at the far end of the valley. I made sure that lots of white paper remained to add to the tonal range and retain plenty of light in the scene. Sparkle and movement were very important to give dynamism to this painting, also enhanced by the low viewpoint. I made the decision to spatter some orange ink onto the work, and although I had taken a risk by introducing another colour, I was pleased and excited by the result – the depth increased and the orange acted as an accent to the somewhat reserved palette. Last-minute additions can work well, but this is not always the case!

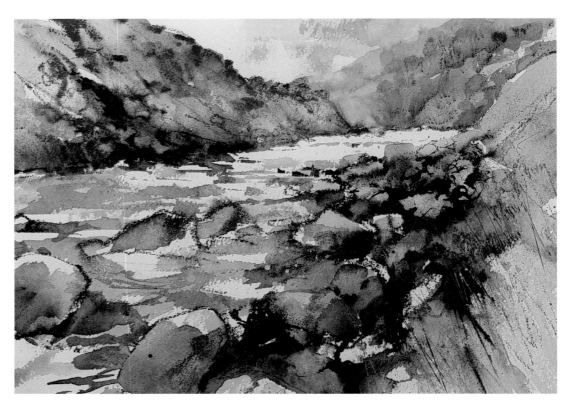

Watercolour, acrylic paint, ink and oil pastel

This technique brings together all four mediums, an exciting, creatively unpredictable combination, and gives you the freedom to experiment and explore how they work together. Oil pastel, used both as a resist to the initial watercolour application and as an addition to the painting in its later stages, works well with the ink to create strength of tone and structure and good lights and darks. I usually keep acrylic paint until last and use it for extra-light areas and highlights, and possibly for strong colour accents to add impact to the painting.

DEMONSTRATION

A Quiet Cove

The line of neat white cottages along the banks of the small inlet on the loch adds a little structure to this rocky, wooded composition. I chose watercolour, ink, pastel and a small addition of acrylic paint that combined to create an unpredictable appearance and a hint of structure in the cottages that emerges from the free painting and mark-making technique.

MATERIALS

Watercolour
Raw Sienna
Burnt Sienna
Payne's Grey

Oil pastel
Indian Yellow
Cadmium Orange

Acrylic ink
Payne's Grey
White

Acrylic paint
Titanium White
Cobalt Blue
Quinacridone Magenta

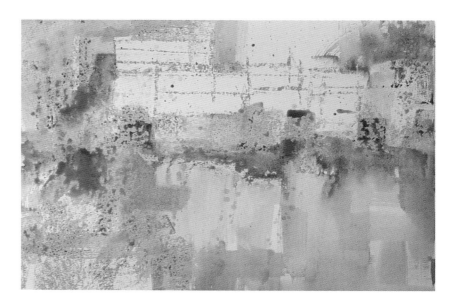

Step 1 After making a very loose drawing of the subject using Indian Yellow and Orange oil pastel I added watercolour washes of Raw Sienna and Burnt Sienna, dashed in quickly and leaving large areas of white paper exposed. This preserves the light in the painting from the outset and can be helpful in later stages of the work.

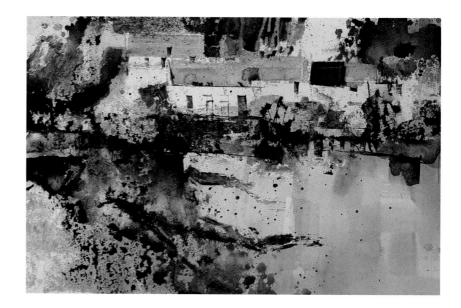

Step 2 At this stage I needed to make sure the structure was firmly established. Once the previous washes were dry I added strong, dark watercolour, letting Payne's Grey and Burnt Sienna puddle and spread together with little control, just enough to define the shapes around the buildings and the edge of the wall and shoreline. I also added hints of building details, such as windows and doors.

Step 3 Next, I added small amounts of detail and also a boat on the shallow water. The reflections add to the glaze of the surface and keep this area as a useful contrast to the busy quality of the rest of the picture.

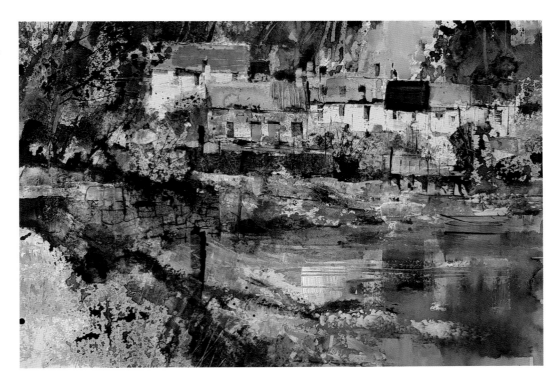

Step 4 Small colour additions were made to the small tethered boat and a mix of Cobalt Blue and Titanium White acrylic was applied to the small patch of sky and its reflection in the water below. I also picked out window details, ropes and twigs with white and Payne's Grey ink. This adds another layer of information to this loose painting and creates visual interest.

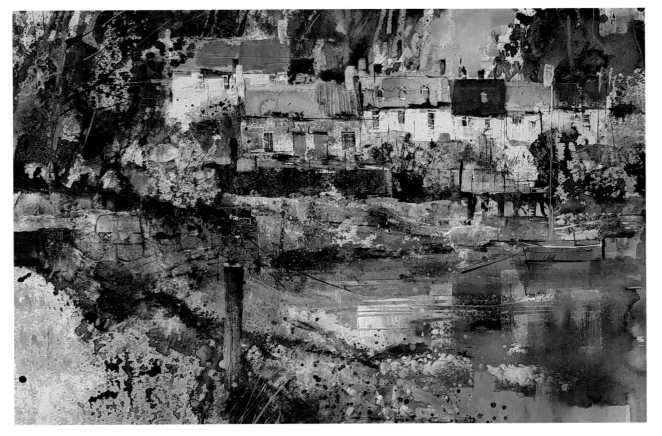

A Quiet Cove
33 × 48cm
(13 × 19in)
*Watercolour,
acrylic paint, ink
and oil pastel on
acrylic paper*

Acrylic paint and ink

The versatility of acrylic paint and ink make them a great duo to combine in a painting. The paint can be used in an opaque or transparent way, applied first as either a wash or a thicker layer of paint, followed by the ink applied over the top in a loose or more considered approach.

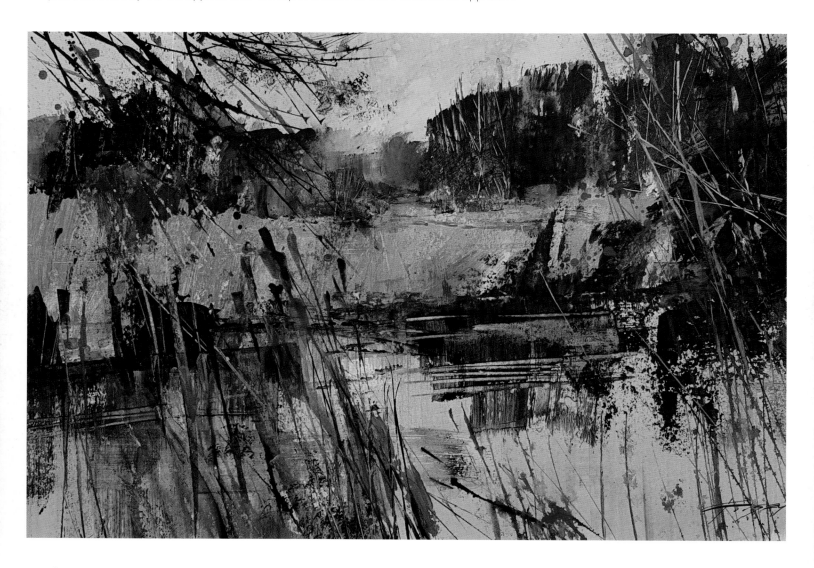

River, Reeds and Winter Trees
30 × 40½cm (12 × 16in)
Acrylic paint and ink
on acrylic paper

I used some imagination for this painting, the colours being selected because I like their relationship with one another – the horizontal band of Yellow Ochre and Cadmium Orange against the complementary blue water, the dark trees in Raw Umber adding strong contrasts of shape. I started with the blue, laying colour in as a transparent wash, then painted the riverbank in broad strokes of acrylic. I used black and brown ink to describe the branches and reeds and plenty of scratching into the paint to bring out the lighter reeds and twigs. Lastly, I splattered and dropped ink and acrylic paint to add a few remnant leaves.

Tin Mine, Frost and Early Light
24 × 34cm (9½ × 13¼in)

Acrylic paint and ink
on acrylic paper

I sketched this scene when walking a Cornish coastal path in late summer, but when I came to paint it I decided to change both season and time of day. I used two blues here, Ultramarine and Dioxazine Violet acrylic paint, painted very loosely and with a lot of water to create an interesting textural foreground. I painted around the buildings to illuminate their shape, adding strong darks to the distant silhouetted landscape using Violet acrylic ink and Ultramarine Blue paint applied together. Next I added the yellow sunshine using Cadmium Yellow ink and paint, and then I had great fun splattering yellow into the foreground and onto the buildings to add a useful complementary colour. The linear descriptive work was added by using Violet ink flooded into the damp paper and then scratching and scraping posts and telephone poles out of the sticky paint and ink before it dried.

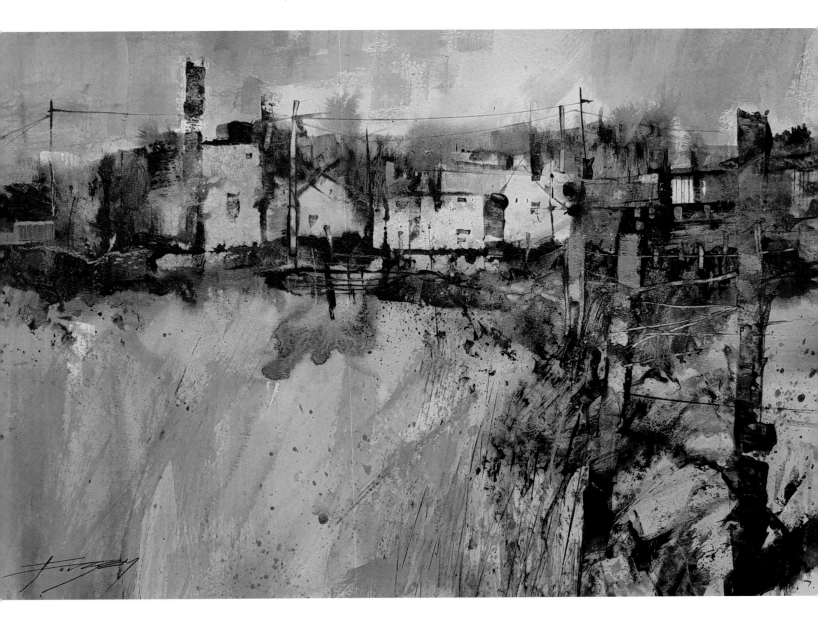

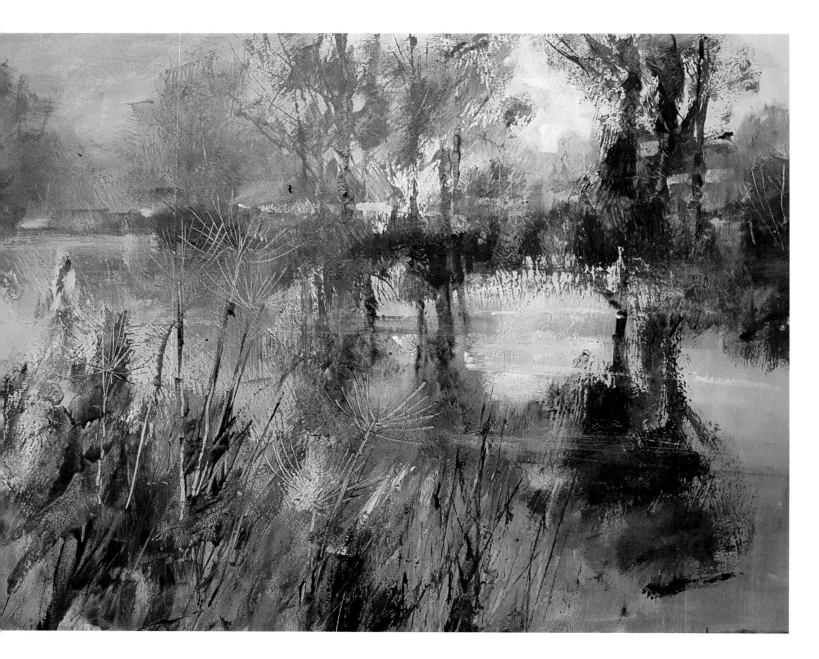

October River

51 × 76cm (20 × 30in)

*Acrylic paint and ink
on acrylic paper*

This river scene would have been well known to the artist John Constable, as it is a walk that he would have made between Dedham and Flatford in Suffolk, his home. The atmosphere in the scene was very appealing, with the early morning mist rising off the river and the autumn trees silhouetted against a pale grey sky. I used very few colours – Cadmium Yellow, Raw Umber and Indigo acrylic paints and Burnt Umber acrylic ink. The initial colours were then washed over with paint and ink more or less simultaneously, using a palette knife and a 50mm (2in) brush to describe everything. I finally used my fingernail to scratch into the sticky pigment as it dried to describe grasses and a couple of umbellifer stalks.

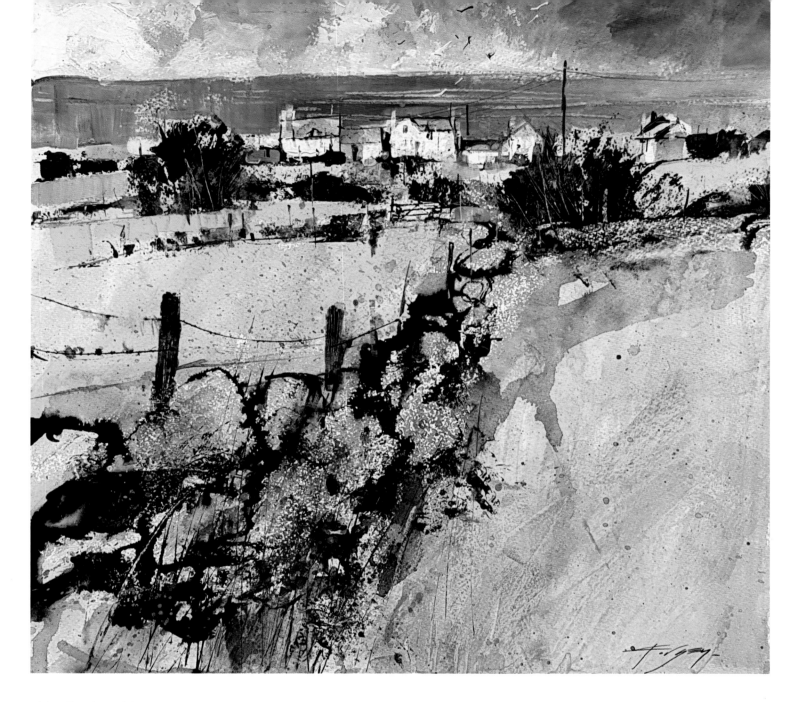

Old Wall and Cornish Cottages

40 × 40cm (15¾ × 15¾in)

Acrylic paint and ink
on Not watercolour paper

I made the first marks with a wax candle to break up the pigment, then used thin acrylic paint and ink to describe the foreground wall, followed by random spatter for more texture. The cottages were described simply, using Payne's Grey ink, and, when dry, form was given to them by adding a Payne's Grey and Titanium White mix for the slate roofs and walls. Ink was then applied very loosely for the autumnal trees and bushes, allowing paint and ink to wash together to create unpredictable shapes and shadows. I painted the sea and sky last and created the edges of the fields on the cliff, using clean Prussian Blue to add a sunny feel to the scene.

Towards the Blue Hills

Have a go at making a painting using tools other than a brush – it's a great way to enjoy the mark-making that each tool offers you, interesting and variable.

MATERIALS

Acrylic paint	**Acrylic ink**
Lemon Yellow	Burnt Umber
Prussian Blue	
Raw Umber	
Yellow Ochre	
Titanium White	

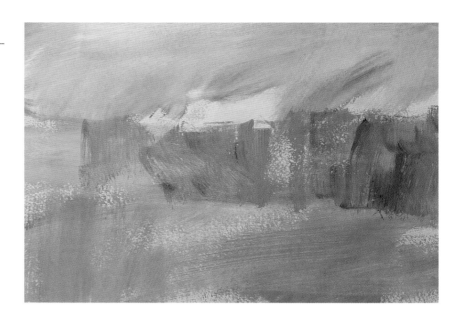

Step 1 First I laid down three bands of colour to key the mood and general colour direction of the painting. I avoided anything that displayed specific shapes, except blue for the top third and Lemon Yellow and Yellow Ochre for the rest.

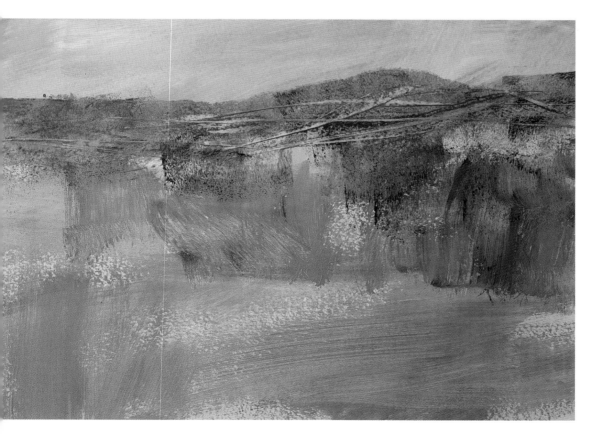

Step 2 Now came the exciting part. I tore a piece of layout paper to act as a mask edge that would resist the paint along the top edge of the hillside then, using a sponge roller, applied Prussian Blue to the top of the painting to describe the distant hills. The roller applied a fairly flat area of pigment with interesting tiny stipple marks in the paint. As this dried I dragged my fingernail across it to roughly describe lighter shapes and patches.

Step 3 For the landscape in the middle distance, I turned to the hard rubber roller. This provided a more unexpected series of marks, as the paint did not transfer from the roller in quite such a flat way as from the sponge roller. I used a paper mask to retain a hard straight edge as the bottom of the shape and applied a mix of Raw Umber, Yellow Ochre and a small amount of Prussian Blue. As it dried, I again scratched and manipulated the sticky paint to reveal the colour underneath and describe fields and clearings in between the trees.

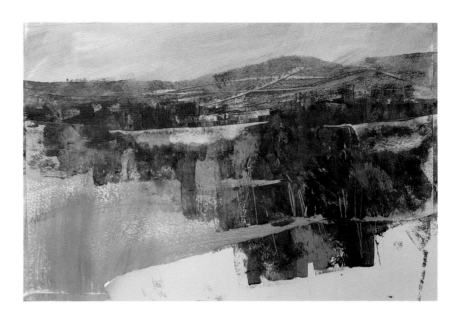

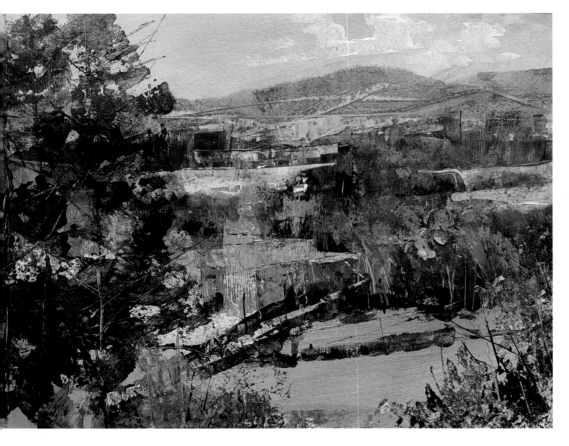

Step 4 Using the edge of the hard roller and acrylic paint to make a linear mark, I described hedgerows and field divisions, scratching a few marks into the sticky paint. I then used the roller with a dark mix of colour to paint the trees on the left, applying the pigment randomly but endeavouring to capture the habit of pine trees. I also applied a bright green using scrunched-up cellophane and kitchen towel for the foreground tree canopies. The final marks were made with ink on the palette knife to add a few branches to the trees and any random details that I felt necessary. I used a tiny amount of white paint for the small cottage in the centre middle distance and the chalky track leading to it between the hedges. Finally, I added a few fair-weather clouds to the sky.

Towards the Blue Hills
27 × 40cm (10¾ × 15¾in)
Acrylic paint and ink on acrylic paper

Water-soluble pastel and oil pastel

This combination of media is an interesting one, giving a very distinctive look to a painting. The water-soluble pastel is almost identical in appearance to oil pastel, but its characteristics are very different. The soluble pastel breaks up when water is layered onto the mark, creating a wash of colour that can have a texture if not too much water is used, or breaking down entirely to give the look of a wash of watercolour. The oil pastel, on the other hand, is stable and untroubled by water, and will repel a wash laid on top of it. So, these characteristics can offer an exhilarating and somewhat unpredictable painting method.

The colours of water-soluble pastel are very clean, bright and powerful and look a little unreal unless you lay one colour over another to subdue their strength. A little softening with water can also be helpful. Nevertheless, water-soluble pastel can be an exciting and creative medium to use, heightening the palette, and they can prove excellent for sketching as you only need a brush and water to create a brightly coloured painting, with no paints required.

DEMONSTRATION

The Downland Chalk Path

My colours for the painting here are virtually primaries, but the heightened colour scheme adds to the feeling of sunshine, summer and light. The surface chosen for this little painting is a Not watercolour paper, which happily accepts the combination of pastel and the clean water wash. My palette of colours was designed to create the bright, fresh look of late spring or early summer.

MATERIALS

Oil pastels
Light Magenta
Cadmium yellow

Water-soluble pastels
Prussian Blue
Mid Green
Burnt Umber
Violet

Step 1 I began by drawing with a combination of oil pastel and water-soluble pastel, the former to act as a colour resist to the water and the latter to supply the hues required for the washes. This needed some consideration about the items to be retained, for example the pink flowers, and where just a wash would be required.

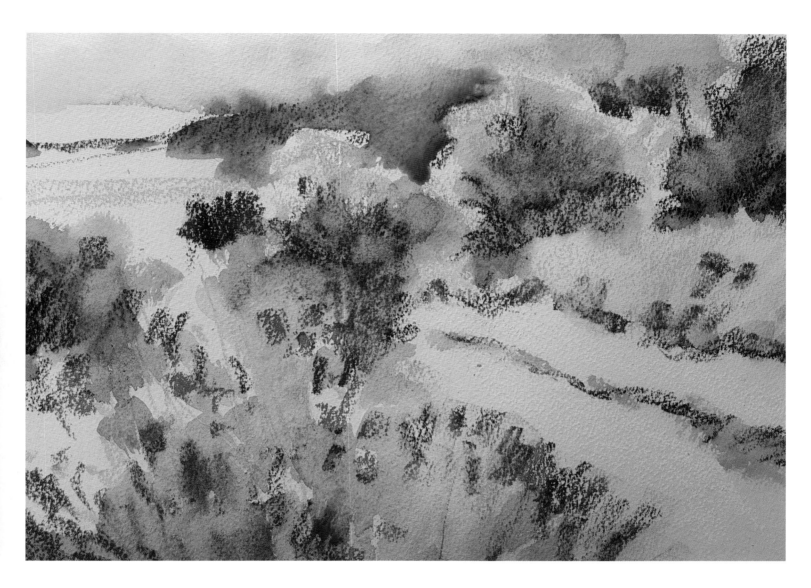

Step 2 The next step needed just a paintbrush and clean water to break up the pastel and create wet washes of brightly coloured hue. As the darker shadow areas dried, I added more blue and a green water-soluble pastel that broke up when added to the damp wash, darkening the greens into a bluer shade.

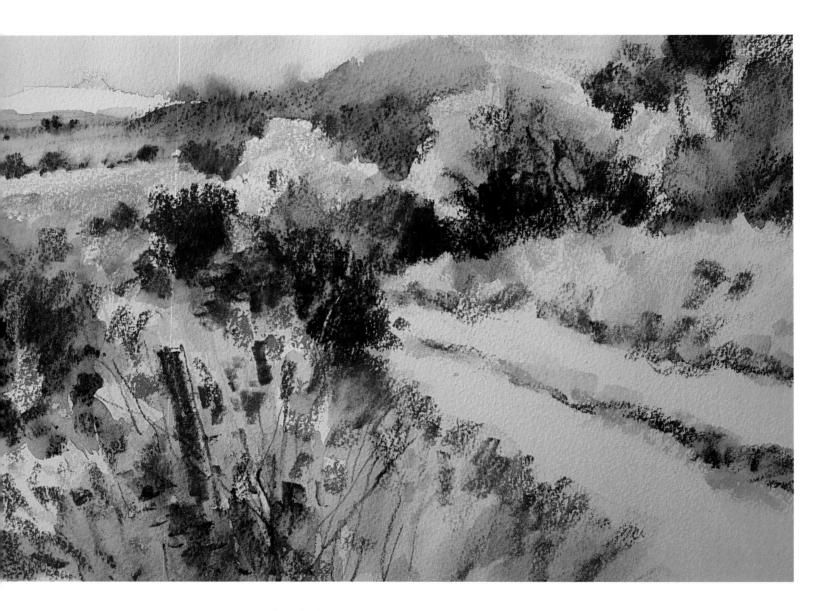

Step 3 The tonal range and depth of hue had been reduced by the addition of the wash, so at this point I decided to add more water-soluble pastel to darken some of the areas of shadow and create a little more depth in the scene. I added some stronger Indigo pastel to the trees and bushes in the middle distance and put in a few more shadows around the pink blooms in the foreground. I used a deep Indian Yellow to describe a cornfield in the distance and added a little of this to the foreground verges.

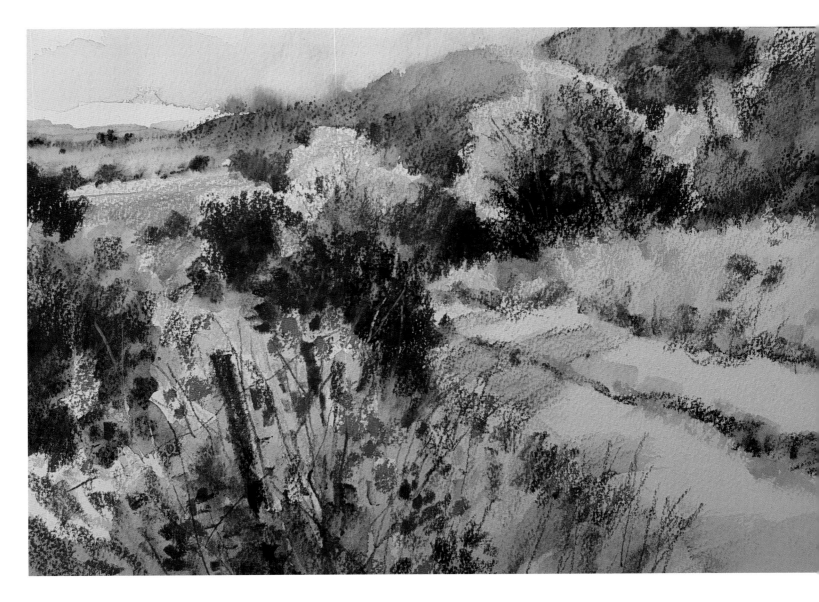

Step 4 For the final touches, I darkened the shadows with Burnt Umber water-soluble pastel. I also decided to enhance the sense of sunlight in the painting by adding a purple shadow cast across the white chalky path, tempered by some water, but still retaining a little texture. I added a fence wire and a few stalks to the colourful foreground. The heightened colour scheme adds to the feeling of summer.

The Downland Chalk Path

34 × 24cm (13¼in × 9½in)

Water-soluble pastel and oil pastel on acrylic paper

CAPTURING THE MOMENT

This final section explores how to take your mixed-media work further, to create specific effects and address particular subject areas. Here I discuss how to recreate the drama of waves and water, how to create convincing textured surfaces and incorporate collage into your work. Finally, I touch on how to give interest to your paintings with small additions, and the joys of semi-abstraction.

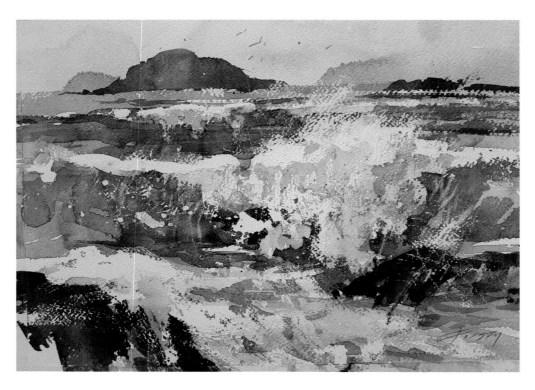

Rocks and Rollers

30 × 40½cm (12 × 16in)

Watercolour and oil pastel on Not watercolour paper

This painting was made using no reference, just my memory. I wanted to capture the translucency of the water, the rising of the wave and the dramatic breaking as it tumbled over, creating a frothy, sparkling plume of turbulence. The depth in the work is based on scale, as we can see two or three smaller waves coming in behind the front-runner. It is the fleeting moment that makes water such a challenging and exciting subject to paint. The colours are Prussian Blue, New Gamboge, Payne's Grey and Raw Umber watercolour and white oil pastel. I also used masking fluid to preserve white paper.

Waves and water

Waves and tumbling breakers defeat the efforts of many artists to convey their movement, transparency and drama. I remember being overwhelmed many years ago by a painting of a wild ocean breaking over rocks and beach that I saw in a gallery window. This painting by an artist whose name I have forgotten has stood as a benchmark for all other wave paintings since, and usually they fall short! However, it is a great subject to try, and using mixed media can be as exhilarating as surfing the waves themselves.

The use of a photograph as a reference can help, but you might find it a hindrance as the temptation is to copy the static image too carefully. As with painting clouds, observation over a prolonged period can be more useful as it creates images in the memory and gives an understanding of exactly what occurs as a wave crashes or a cloud scuds by. The thing to capture is the essence, the drama and the elemental wetness of the waves, and the fact that they are fast-moving, ever-changing from moment to moment, and no two are ever the same. Their appearance is also very dependent on the weather and light, the colour altering from one hour to the next, and this is where an understanding gained by direct observation can aid the rendition of the subject in a convincing way.

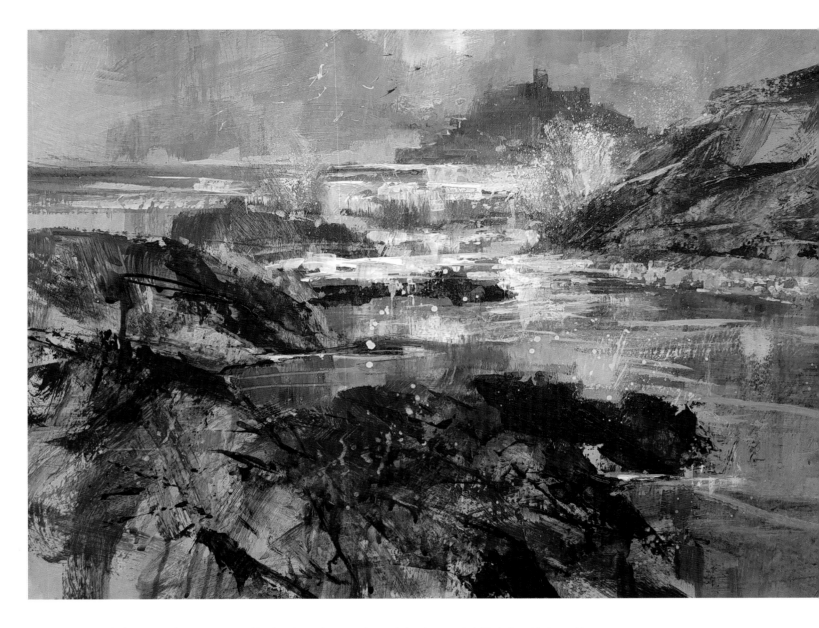

Rocks, Waves and Distant Castle

28 × 39cm (11 × 15¼in)

Acrylic paint on acrylic paper

This view is made more dramatic by the low angle of view, and I endeavoured to create a painting full of movement and action. I underpainted the whole surface with a thin wash of Yellow Ochre to begin with, which gives the painting something of a sunny mood and also helps with the contrast of the white, splashing waves. The foreground rocks were painted very

briskly in Raw Umber with a smear or two of Dioxazine Violet. I also used Burnt Umber ink to give texture to the rocks. The waves and foam were painted last, when the previously applied paint was dry, using a toothbrush to spatter white ink and a palette knife to describe the waves and moving water.

Wave Break

The movement of a developing wave, from the swelling water to the curling and breaking wave, is always a challenge. The movement and drama of the event seem paramount when trying to paint it, and so I chose the immediacy and looseness of watercolour with the addition of oil pastel to break up the water's surface and create the texture of spume and froth as the wave breaks.

MATERIALS

Watercolour
Prussian Blue
Payne's Grey
Lemon Yellow

Acrylic ink
White

Oil pastel
White

Step 1 I approached this painting of a breaking wave with only memory as a reference, so I wanted to paint just the general feeling of a tumbling wave of water, a brisk wind catching the crest of the wave and creating a plume of frothy white water. My first marks were made with a white oil pastel, dragged on its edge across the surface of the paper. I chose to depict the wave breaking off-centre in the composition to avoid any symmetry in its appearance and give it more visual dynamism. Onto this I brushed a blue-grey mix for the sky and a more intense wash of Prussian Blue on the ocean surface. Behind the wave and where the curve of the wave is rising, I added Prussian Blue with a touch of Lemon Yellow to push it towards a slightly more turquoise blue and create a look of transparency. The pastel resisted the watercolour and left areas of speckled paint, ideal as a way of representing the frothy water.

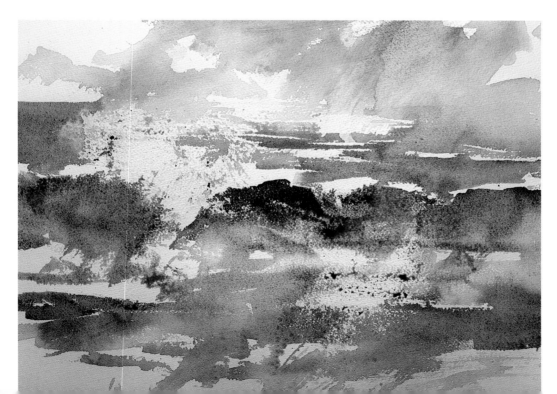

Step 2 As this first loose wash was drying, I added a darker wash of Prussian Blue and Lemon Yellow, with a little Payne's Grey dropped in just below the white crest to add to the curving and breaking appearance of the rolling wave, and also a little more Lemon Yellow to add colour intensity and bring the wave a little forward from the waves behind it. I also decided to add a rugged headland in silhouette to further increase the appearance of depth in the scene.

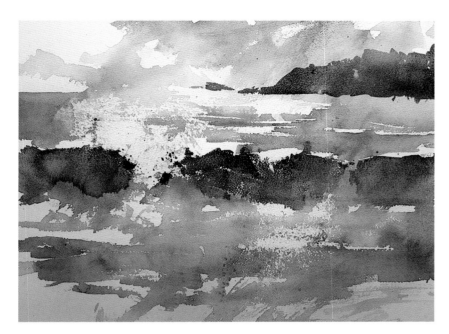

Step 3 When this paint layer was dry, I wanted to add a few more marks to describe the foam of the rolling wave. For this I used white acrylic ink. I dragged the point and edge of a painting knife carrying the ink across the face of the wave and made marks to create a feeling of movement and its imminent breaking. Using a toothbrush laden with the ink, I also added spatter to the areas I considered best for this frothy blur of foam. The flicks of pigment were added almost at random but with just enough control to describe the exciting anticipation of the final breaking line of the foam as it crashes onto itself beneath the curve of the wave.

Step 4 I think I stopped at the right moment with this painting, with enough of a loose suggestion of the wave before I could get too involved with detail and destroy the immediacy of the painting. I added just a touch of blue to the sky to increase the feeling of a break in the scudding clouds and the promise of a lovely sunny day – and maybe even a dip in the ocean!

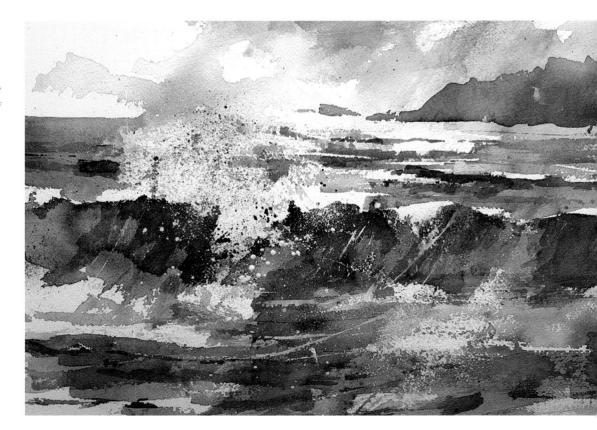

Wave Break

26 × 38cm (10 × 15in)

Watercolour, ink and oil pastel on paper

Down by the River

The riverine environment is a very exciting and variable subject for the artist, and it is one of my favourites. Not only do I enjoy the sky reflected on the water, creating light and movement, a river allows my eye to follow it through the painting from close-up riverside detail in the foreground to distant trees and hills. A river also tends to create a haze above it, which can help in the exploitation of depth and distance, with aerial perspective enhanced by the diminishing clarity of the detail of trees and flora on the riverbank.

There is a great deal of difference between the tumbling waters of mountain streams strewn with rocks and boulders and a more sedate river meandering through a lowland environment. Both subjects are very rewarding and challenging to paint, offering many opportunities to capture the atmosphere of the scene in your work.

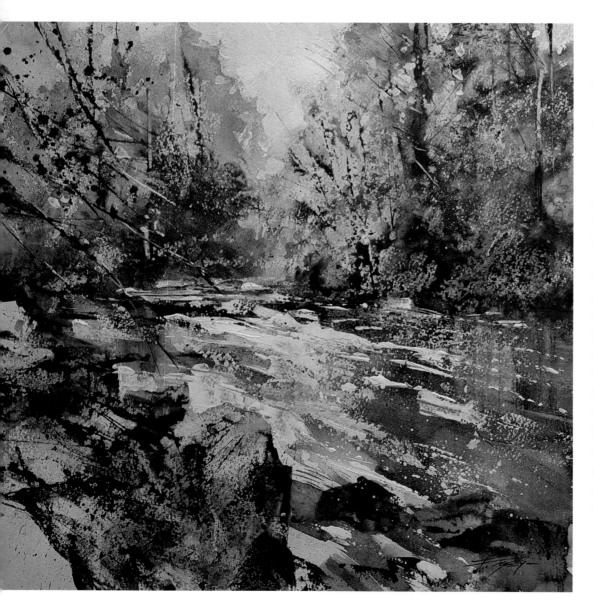

Fast-flowing River
35½ × 35½cm (14 × 14in)
Watercolour, oil pastel and acrylic ink on acrylic paper

A river in the Welsh mountains tumbling at speed around a tree-lined bend provided the inspiration for this painting. Using an initial layer of yellow oil pastel mark-making, I then washed in Dioxazine Violet and Indigo watercolour in the shadows, the trees and the water, allowing the purple to run down to suggest reflections. The pale Indigo in the distance enhances the sense of depth. When these washes were dry, I indicated the cracks and shadow in the foreground rocks using the sharp end of a palette knife and added branches and suggestions of tree structure. I used smears and marks of white acrylic applied with the knife to suggest the foamy waters plunging between the trees and rocks.

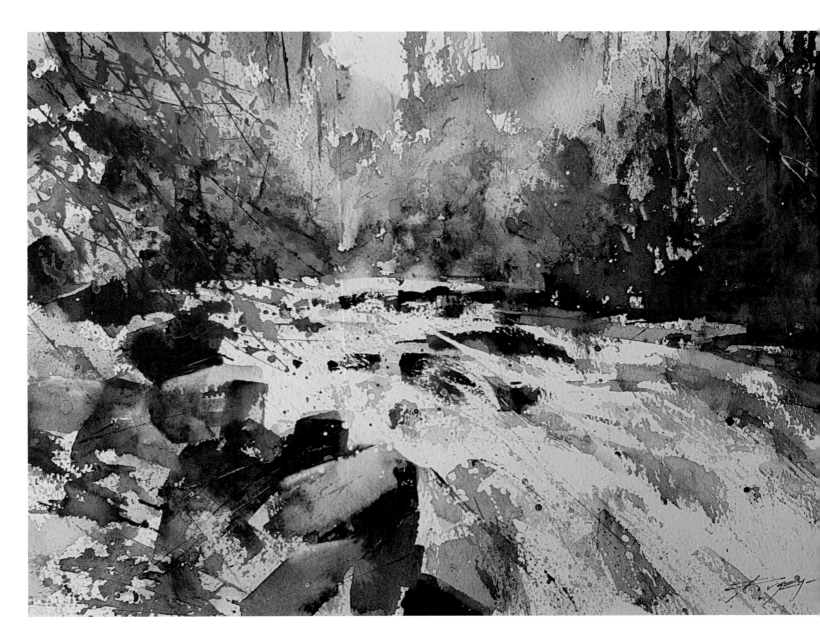

Mountain Waters

25 × 30cm (9¾ × 12in)

Watercolour, acrylic ink and oil pastel
on Not watercolour paper

The spectacle of tumbling, crashing waters over river rapids was the inspiration for this painting. I wanted the largest and brightest part of the painting to be about the surging river, and I left most of this area as white paper, augmented by splashes of white acrylic ink and touches of white oil pastel. I chose a simple palette of colours: Payne's Grey, Cobalt Blue and Lemon Yellow watercolour with splashes and spatters of Orange ink for the tree on the left. This helped to create a little more depth in the work and break up the overall coolness of the colours.

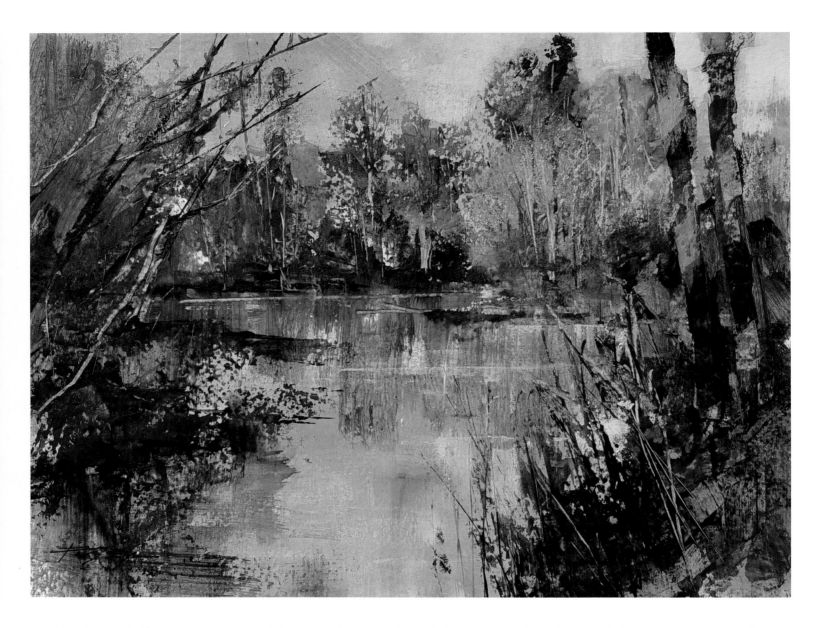

Yellow Tree Reflection

22 × 33cm (8½ × 13in)

Acrylic paint, ink and oil pastel
on acrylic paper

Calm, unruffled rivers can offer a challenge as they lack the drama created by waves and turbulence. My approach here was to rely on a few simple but well-placed vertical sweeps of the brush in a downward movement, ensuring the marks were placed directly underneath the objects above that are reflected. These brushstrokes naturally have broken edges and a lack of detail, and are also lighter in tone and depth of colour than the object itself. Once these areas were dry, I dragged horizontal strokes of light paint across the surface to represent the movement as a light breeze ruffled the water. This added a sense of reflection on the surface of the water and also helped to confirm that this is water and not sky – an element that is sometimes a problem in more abstract paintings.

River and Summer Mist

28 × 40cm (11 × 15¾in)

Acrylic paint and ink

on acrylic paper

This scene by the river one July morning offered a splendid opportunity to capture sparkle, mist and sunlight in a painting. The composition of the meandering river encourages the eye to travel to distant objects. The complicated mass of dark trees on the left has a much-simplified reflection beneath; I achieved the sense of gently rippling waters by moving the flat brush downwards in a wriggling, dancing progression, giving the edges of the mark a slightly ruffled edge. I used white acrylic ink to create the sparkling reflections of sunlight and also to flatten out the reflective surface of the water on the distant river bend. The mist on the river was achieved by applying Titanium White and a small amount of Cobalt Blue as smears on top of the previously dry surface, using a flat 25mm (1in) brush, a piece of kitchen roll and my finger to soften the mark.

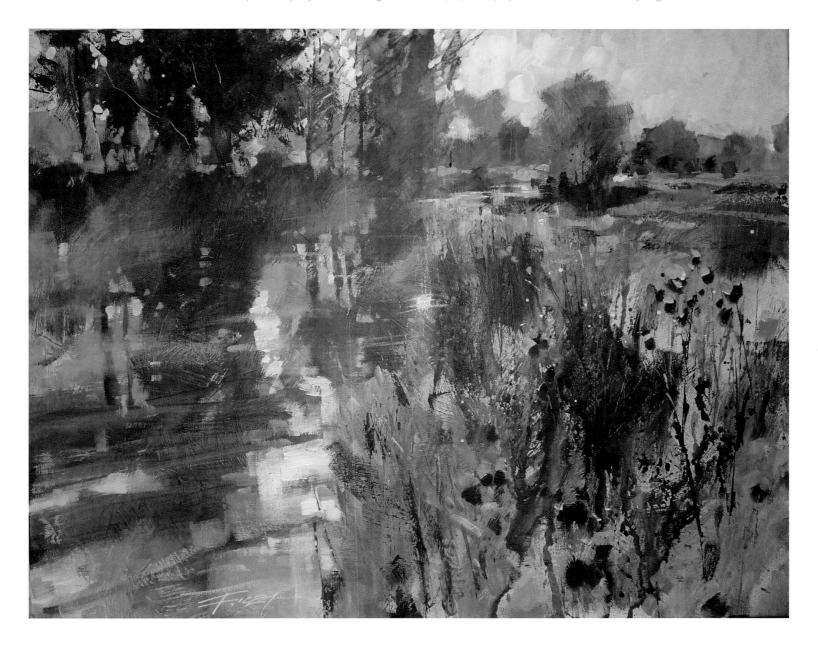

Beached boats

The sight of a vintage boat hauled up on a beach, mudflats or reed bed appeals to many artists. This subject can offer a lot of landscape painting opportunities as, of course, there are always elements such as trees, grass, mud and shingle, background cliffs, a cluster of old wooden sheds or a pontoon. In fact it is one of my favourite subjects, not least because it often provides old, textured surfaces for which mixed-media treatment is ideal.

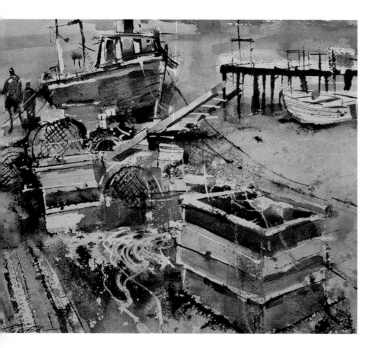

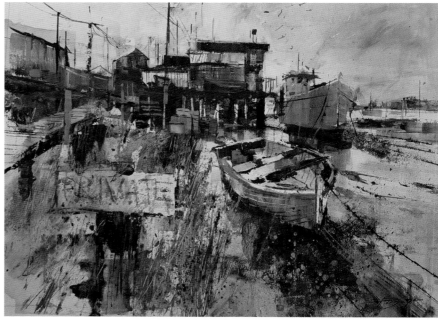

Beach, Boat and Boxes
33 × 45½cm (13 × 18in)
Watercolour, ink and oil pastel on Not watercolour paper

I was attracted by the pile of fish boxes, nets, lobster pots and so forth that were strewn in a line towards the boat on the shore. I used Cobalt Blue, Lemon Yellow and Cadmium Red watercolours for this, allied with Payne's Grey acrylic ink, masking fluid and a little oil pastel. The jumble of objects presented a good opportunity to combine materials to provide texture and description. White acrylic ink was very useful for describing the sunlit top edges of box, boat and other nautical details.

Muddy Beach and Boatyard
40½ × 51cm (16 × 20in)
Acrylic paint, oil pastel and acrylic ink on acrylic paper

Interesting silhouettes and vintage boats, posts and other boatyard items grabbed my attention immediately. The sheds and rustic buildings provided a good set of background shapes and the rotting hull of the little rowing boat and the old 'Private' sign gave me a good foreground grouping to take the gaze further into the painting. The colours I chose for the required impact were Cadmium Orange, Raw Umber, Cobalt Blue and Yellow Ochre acrylic paint and a little Titanium White.

Crowded Harbour

40½ × 51cm (16 × 20in)

Acrylic paint, ink, oil pastel, black water-soluble crayon and collage on acrylic paper

In this painting I combined linear washes and colour blocks with small additions of paper torn from magazines and other print media. This gives the painting a more abstract appearance, enhanced by my endeavour to give a slightly flat look to the work with little in the way of perspective and depth. Primary colours alongside neutral greys and browns create a strong, graphic appearance, and the use of acrylic paint, ink, oil pastel and water-soluble crayon gives an intriguing paint surface enhanced by some collage.

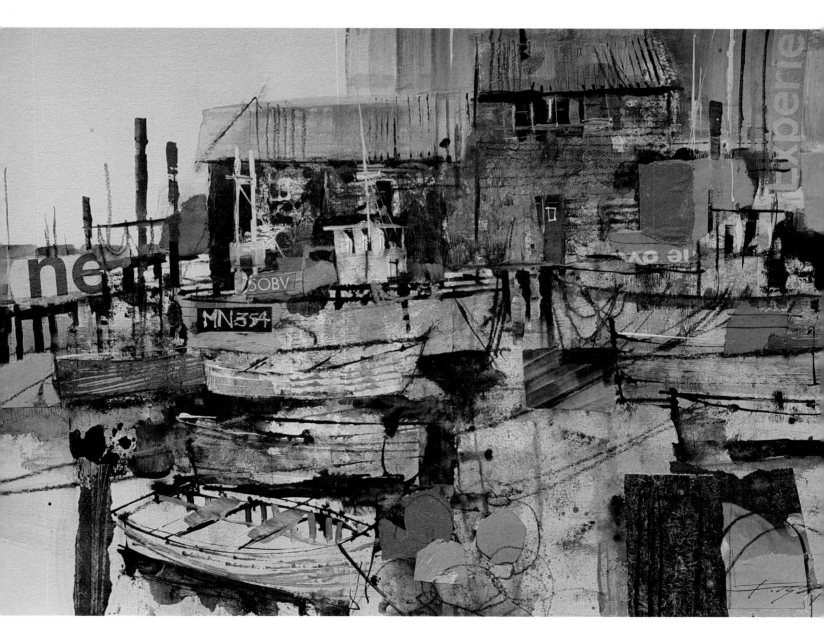

Creating a textured surface

Mixed media is marvellous for creating the appearance of texture and weathered surfaces in a painting. By choosing and using tools such as toothbrushes, rollers, stiff brushes and others you can create a realistic result. Some experimentation might be a good idea, however, to see which combination works for the subject area in which you are painting.

DEMONSTRATION

The Old Hull

This section of the prow of an old boat shows how you can use a combination of mediums. Here I used watercolour, oil pastel, ink and acrylic paint to create a textured surface that can be used not only for boats but all sorts of weathered, antique surfaces.

MATERIALS

Watercolour
Indigo
Raw Sienna

Oil pastel
Yellow Ochre
Cobalt Blue
Cadmium Orange
White

Acrylic paint
Titanium White
Indigo

Acrylic ink
Payne's Grey

Step 1 I began by drawing, scrubbing and smearing a layer of Ochre, Orange and white oil pastel onto the paper, then loosely applied a wet wash of Indigo watercolour over the top of the hull. This created a very textured appearance, the watercolour clinging to the areas of blank paper and rejected as small droplets over the pastel. I used a mix of Raw Sienna and Indigo watercolour for the rendering of the upright mooring post.

Step 2 As the layer of oil pastel and watercolour began to dry, I picked up my palette knife and Payne's Grey acrylic ink and, using the edge of the knife, described the boat timbers. The more broken this mark the better, to add to the weathered appearance of the wood. I also dragged ink across the surface of the mooring post to emulate the exposed grain of water-degraded timber.

Step 3 Once this layer of paint and ink was dry, I decided to augment the work with a small amount of acrylic paint. I wanted to retain nearly all of the previous layers of marks, but I thought a certain amount of additional opaque pigment would add to the description of old paintwork. I used Titanium White and a small amount of Indigo to make a few marks on the timbers and added a name plate using a child's printing kit to print a few letters on it. Lastly, I added a mooring rope to the post, using ink and Blue pastel to complete the little painting.

The Old Hull
26 × 26cm (10 × 10in)
Watercolour, oil pastel, acrylic paint
and ink on acrylic paper

The Autumn Valley

This approach to mixed media offers many opportunities to lay one opaque layer over another, creating texture and densities of hue that can be altered at any stage by applying another layer of pigment, either acrylic or pastel, over the top. It works best on a fairly smooth paper or gessoed card that has been rubbed with sandpaper to smooth the surface. This surface allows for scratching and mark-making into the paint when it is still sticky or completely dry. I chose this subject and pairing of mediums as they gave me the chance to depict the trunks and increasingly bare branches of the autumn trees with the scratch-out method. I used harmonious, warm colours, as befitted a painting of autumn.

MATERIALS

Acrylic paints
Raw Umber
Payne's Grey
Cadmium Yellow
Cadmium Scarlet

Oil pastels
Cadmium Yellow
Orange

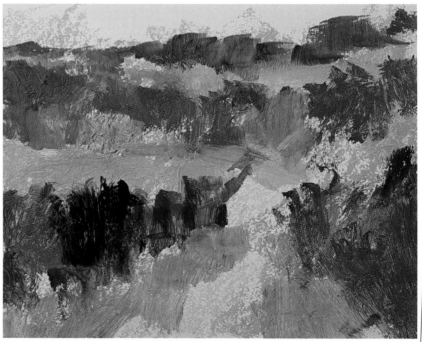

Step 1 I find that this technique of manipulating acrylic paint works best if the process begins with a layer of freely applied oil pastel. Scrubbed and rubbed all over the surface of the paper or card, this creates a very unstable surface for the acrylic layer, making it easier to scratch into the paint as it dries and reveal the colour of the pastel underneath. I did this by removing the pastel's paper wrapping and using it on its broad side.

Step 2 Next, I painted over this surface with the acrylic paint. I applied it in flat blocks of colour, distributing the limited range of hues to offset each other and largely disregarding depth and form. I saw the painting as a patchwork of colours suggesting autumn trees descending into the valley, so a lack of perspective was suitable for my vision. I added a small amount of acrylic retarder to these colours when they were laid out in the palette, as this would increase the drying time enough for me to manipulate the paint while it was still sticky.

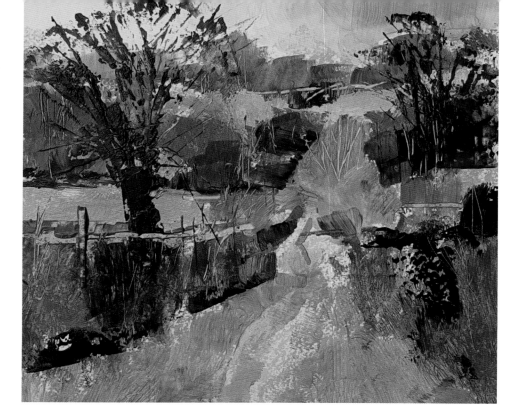

Step 3 As this layer began to dry, I added the larger shapes of bare trees to the left and right, using a palette knife to describe these shapes in a loose and expressive way. Next, with the sharp edge of the painting knife and my index fingernail, I added scratch lines and marks to depict some bare branches and the trunks of the trees.

Step 4 I waited for the acrylic paint to be totally dry before the next stage. I then added pastel marks and scumbled areas over the acrylic to describe clusters of golden leaves clinging to the trees here and there. I wanted to retain the scratch detail and marks, so this pastel layer was done with restraint. Lastly, I picked up the acrylic paint again to describe some shadows on the track and give a feeling of sunlight falling on the scene.

The Autumn Valley
28 × 40½cm (11 × 16in)
Acrylic paint and oil pastel
on acrylic paper

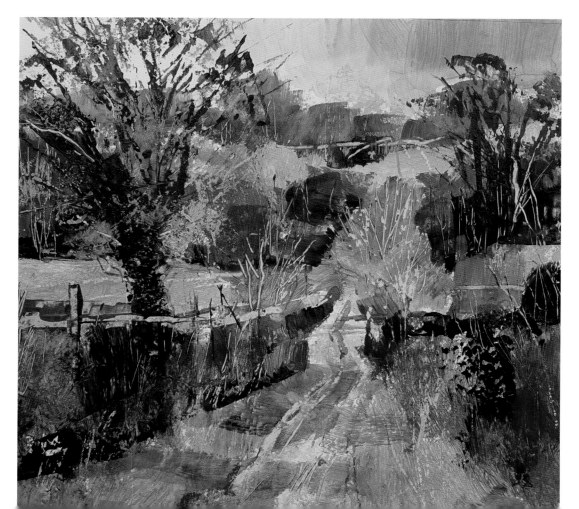

Collage

The collage technique is seen as a fairly recent addition to the artist's media choices, compared to applying pigments that have been used for centuries. It was developed by George Braque and Pablo Picasso as part of the Cubist approach to art early in the 20th century, the additions of newsprint and printed material giving their paintings a graphic, abstract appearance. Collage can also be used to add texture and unusual surfaces beneath paint, upsetting the natural appearance of the medium and interacting with it in a very exciting, unpredictable and creative way that can be used to create the appearance of a natural surface, such as rock, bark, branch and grass.

Collage gives you licence to lose your painting inhibitions, have fun and take a chance. You never know what you are going to get and sometimes the results can open up new opportunities. The collage can be applied in a complex way, with elaborate cut-outs and shapes used descriptively, or it can be used much more simply to equally good effect, creating initial abstract shapes and textures that can be painted over partially or completely.

The French Farm

39 × 49cm (15¼ × 19¼in)

Acrylic paint and collage on board

This cluster of old farm buildings and the wall and foreground rocky corner offered a good opportunity to use collage as a way of starting the picture. I glued large shapes of torn paper to represent the rocks, old wall and buildings onto a board prepared with a Pale Ochre layer of acrylic paint. I then applied broad brushmarks of paint over these shapes to describe grasses and the tree shapes on the left and also the vague, distant shapes of the hillside and trees. I added the post on the right using collaged paper, then added detail to the wall and the buildings.

Village Under the Cliffs

30 × 40cm (12 × 15¾in)

Acrylic paint, ink, oil pastel
and collage on acrylic paper

My approach to this collaged painting was a little different as a lot of the main shapes were applied in the later stages of the painting. The background cliff shapes and landscape were painted in first, followed by a large collaged shape to represent the tree mass behind the village. I used quite a heightened colour scheme for this painting – Lemon Yellow, Phthalo Blue, Cadmium Orange and Black acrylic paints, which gave the painting a sunny, summery mood. The village buildings were then added on top of the landscape, each shape cut from painted papers and patched in, one on top of the other. It was quite a complicated approach, but in this case I felt it was necessary to achieve the patchwork of tonal shapes. The details were added last, using ink and oil pastel. The final painting has a flat and rather two-dimensional appearance, the overlapping shapes giving a lively, playful feel to the work.

Lake and Rocky Scarp

50 × 50cm (19¾ × 19¾in)

Acrylic paint and collage

on gessoed mountboard

I was keen to give this painting a lot of distance and a vertiginous view to the waters of the lake below. I wanted to exaggerate somewhat, so I chose to use a lot of collage on this area. The pale Raw Sienna foreground was studded with rocky cut-out collage shapes in Payne's Grey and Indigo, building a craggy edge to this high ground. The trees beyond this were also collaged, in Dark Green, and the distant mountain silhouette was layered in with collaged papers along with the lakeside trees. I rather elaborately added small orange, yellow and green collage shapes in the very foreground to give added distance to the painting from our viewpoint on the precarious edge of the scarp.

Bridge over the Avon

36 × 50cm (14¼ × 19¾in)

Acrylic paint and collage
on gessoed mountboard

The Avon Bridge is an impressive structure high above the river gorge, and with the group of buildings below it lent itself to a collage approach. Most of the solid shapes are made from collage, apart from the muddy, shallow river, which along with the sky was painted before applying the collage. Small areas of brighter colour add a little colour dynamic to the painting, mostly painted in New Gamboge, Payne's Grey and hints of Burnt Sienna prepared on papers before sticking them on to the support. I tore the papers to create a ragged edge for the landscape, then cut the building shapes in a random way to add more of a formal structure to their sharp outline.

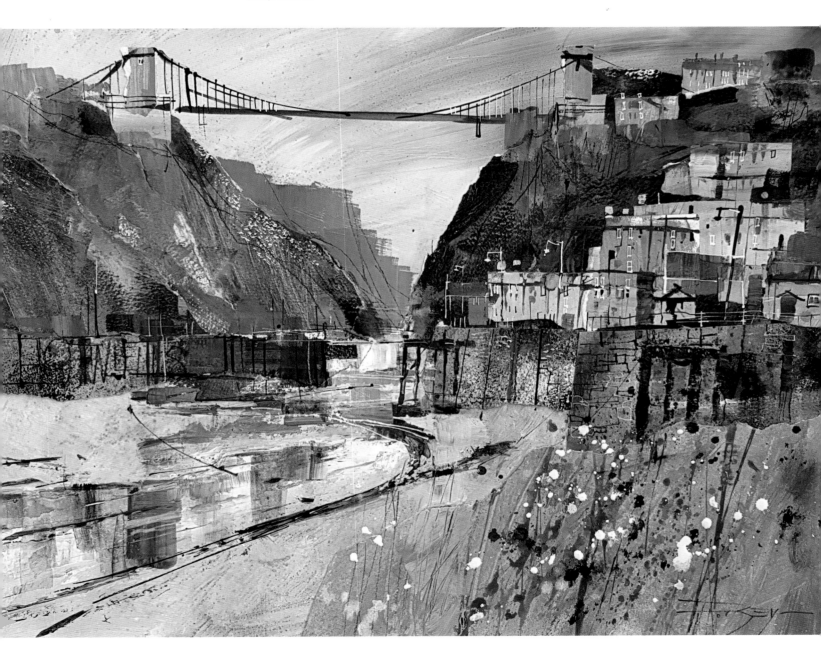

The Scottish Cove

For this piece I was immediately attracted to the fallen rocks in the foreground – what fun that is as collage! – and the impressive highland mountain profile in the background. This allowed me to exaggerate the sense of distance with the warm details and shapes at the front of the picture and cooler blues in the distance. Collage allows you to play with shapes before committing to a final placement, laying them on like jigsaw pieces until the most pleasing design appears. This also allows you to revise the overall composition and shape relationships, and you can add more collage if you feel it is needed.

MATERIALS

Acrylic paint
Dioxazine Violet
Lemon Yellow
Prussian Blue
Titanium White

Watercolour
Quinacridone Gold

Acrylic ink
Payne's Grey

Oil pastel
Lemon Yellow

Step 1 I used watercolour, oil pastel and acrylic paint to create my textured colour swatches. These were painted from Quinacridone Gold, Dioxazine Violet and Prussian Blue, applied very expressively to cartridge paper. I painted large samples, as at this stage the quantities required of any one colour is unknown, and I didn't want to run out of collage during the painting process.

Step 2 I prepared two painted papers with random and loosely applied marks of Dioxazine Violet acrylic paint mixed with a touch of yellow to the colour, then placed them onto the support.

Step 3 Once I was happy that the collaged papers were placed as I wanted, I glued them to the support with PVA adhesive. To add more in the way of description and representational marks, I added a few tree shapes to the promontory on the right of the scene. I decided that a tree shape leaning into the scene would be a useful addition to give added depth to the painting and increase texture in this foreground area.

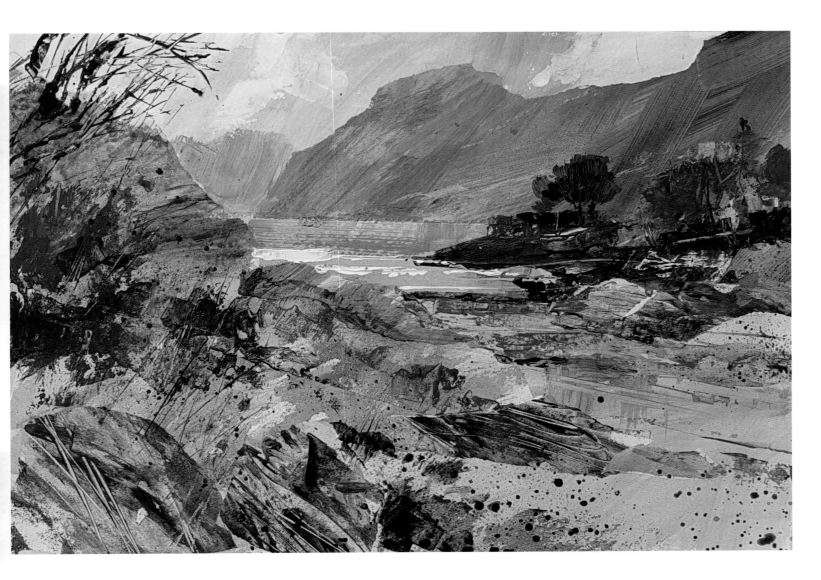

The Scottish Cove

33 × 47cm (13 × 18½in)

Watercolour, oil pastel, acrylic paint and
collage on gessoed mountboard

Step 4 One of the ways you can encourage the eye to travel further into the painting is to add a little detail or a colour that adds a bit of an accent to the work. This thought inspired me to add a small blue boat shape and a whitewashed cottage on the promontory in the middle distance. To finish the painting, I also added areas of spatter, flicked with a toothbrush, into the foreground rocks and sandy shore, and used the same technique to add a few leaves to the tree on the left. After a few other little touches with a brush and painting knife, I considered the work complete. It is tempting to add more and more to a collage painting and thus lose its original shapes completely; stopping early is sometimes better than pushing the work further. It is always difficult to decide when a picture is finished.

Cropping your paintings

It can be useful to consider the possibility of cropping your paintings, perhaps just to reduce the size or because you have spotted a composition that would work better. It is certainly always worth taking another look before throwing away a painting you have decided is disappointing – you may be able to discover three or four alternative works within it, even if they just prompt an idea for another painting. All you need to do is examine the work with a few different-sized mounts and a fresh eye, then cut it to size if appropriate. This is easily done on paper but is more problematic for works painted on canvas or board.

CROP 1

Placing a mount in a portrait format on the painting reveals another composition that offers a totally different experience of the scene. The eye now travels along the snowy path and fence that curve towards the centre, giving more importance to the visual journey into the painting and the large snow-covered tree close to the path. The fence posts and spiky stalks of the grasses by the path are now given much more emphasis and the composition leads one's eye far into the painting as it follows the dark curve.

CROP 2

This small section of the painting increases the importance of the buildings and focuses on their lighter shape against the darker line of trees behind them. This more stratified composition exaggerates the warm tones of the foreground bushes and particularly the band of the shadows across the snow in the middle distance, also emphasizing the sunlit buildings in the background. The two upright trees and telegraph poles against the darker tree mass on the left of the painting are more or less on the vertical axis of the composition and the buildings are on the horizontal axis, thus conforming to a classic compositional stratagem of dividing the picture into thirds.

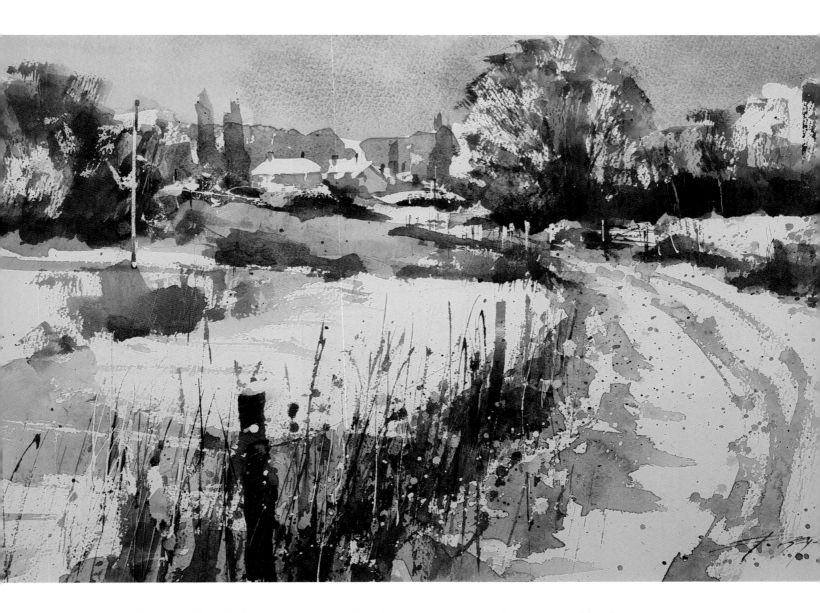

The Snowy Winter Walk

33 × 48cm (13 × 19in)

Watercolour and acrylic ink
on Not watercolour paper

This winter painting seemed to be an ideal candidate for cropping into smaller works as it had areas of the composition that would work on their own. Although the work was quite pleasing it did offer other possibilities as a basis for a new painting or two, based on a new format and size.

Useful additions

A landscape painting is an emotional response to a particular scene. There are, of course, additional features that can give an extra degree of interest and make a landscape come alive, though they must be handled with subtlety and sensitivity otherwise the view can become secondary to them. An extreme example of this would be the *Mona Lisa*, the world-famous painting by Leonardo da Vinci. Behind the woman with the enigmatic smile is an extraordinary landscape that most people hardly notice when looking at the painting. The wonderful portrait would be superb on a black background and the landscape probably marvellous without the beautiful face, but we can excuse him for painting such an astonishing picture. Many landscape paintings by J.M.W. Turner have clusters of people in them, busy in the foreground or middle distance, and adding a sense of animation and focus to the painting. He also included cows and other animals, another way of imparting a narrative to the painting.

In your own paintings, a well-placed group of cows, a flock of birds, wildfowl in a riverine environment and, though it is a bit of a visual cliché, a man with a dog can be very useful to give life to the landscape and also to create small points of focus. Some paintings of landscapes seem to call out for a few small figures to be added, coastal scenes in particular benefiting from their inclusion. The figures may be animated or still, but if kept very small and distant can function as actors playing a part in that landscape by bringing it to life; the effect is that viewers very often place themselves in the scene in their imagination. Scale is very important and locating the figures at some distant place in the scene helps the eye move through the picture to join them.

A group of buildings adds interest – for example, a distant set of factory chimneys, mine workings or other industrial heritage. Boats in a coastal or inland landscape may act as a useful focal point or as an incidental addition to underline the location of the painting.

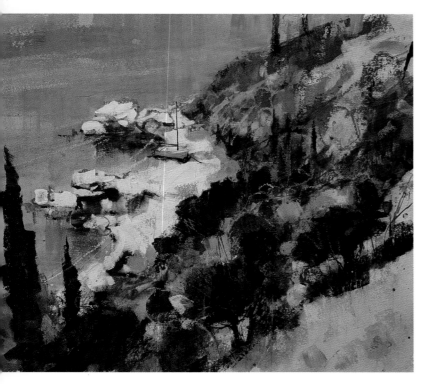

Boat on the Beach
24 × 34cm (9½ × 13¼in)
Acrylic paint, acrylic ink and oil pastel on acrylic paper

The olive trees, cypresses, white sparkling sand and azure waters of the Mediterranean just needed one little addition, and it arrived when a boat was pulled up on the beach by an elderly Greek man. The boat immediately brought a sense of life and purpose to the scene and acts as a focus in this composition, the diagonals of the treeline taking your eye straight to its location. I decided that its colour in my painting shouldn't be too jarring, so I painted it with the colour that it was in reality, endeavouring to preserve the tranquil nature of this small part of a Greek island. My palette included Violet Lake acrylic ink, Yellow Ochre, Olive Green, Dioxazine Violet, Turquoise and Cobalt Blue acrylic paints and small touches of Olive Green oil pastel, excluding red from the work and letting the violet stand in for it.

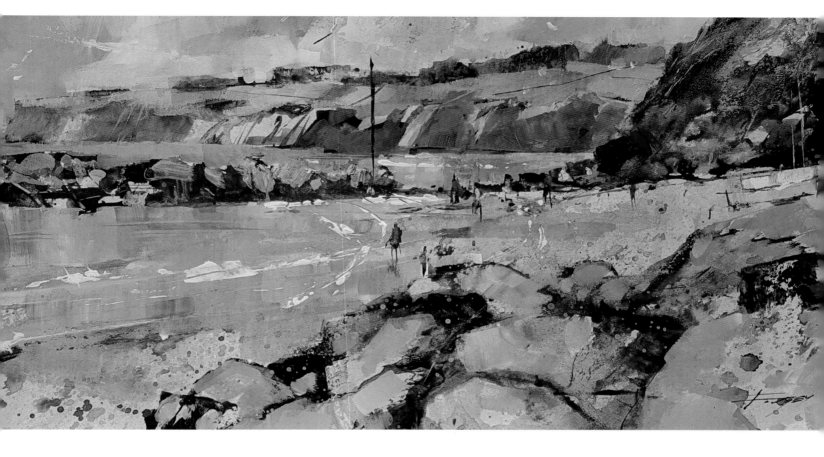

Beach in Summer

26 × 53½cm (10 × 21in)

Acrylic paint and acrylic ink on acrylic paper

For this painting, I really pushed the colours as well as the
format, using Purple Lake acrylic ink, and Lemon Yellow and
Phthalo Blue acrylic paint to create the sun-filled mood of
the summer scene. The addition of the people as the painting
drew to its conclusion helped to transform the scene by adding
movement and scale. At this size, figures can be rendered as
little more than a loose squiggle – a dot for the head, a dash for
the body and the indication of legs and possibly an arm or two.
Getting the scale correct is very important, for if too much detail
is attempted the general impression of figures can be lost. In a
large landscape they serve to indicate the height of the cliff, the
size of the boulders and so on.

A touch of abstraction

It can be said that all painting is an abstraction as it can never completely portray reality in all its detail and colours. Most artists use an element of abstraction in their paintings whether they intend to or not, but setting off with the aim of taking abstraction further can be one of the most thrilling and rewarding endeavours.

Achieving this in your landscape painting is an adventure that can start very easily from some judicious cropping. By taking just a small portion of a painting, sketch or photograph you can discover sets of shapes that can act as a starting point for a painting – interlocking field shapes, the profile of a mountain or shadows cast by trees, for example. In *Downs Beyond* (see opposite) there are broad sweeps of landscape and profiles of tree shapes, the detail on a seedhead as the main focus emerging from a blur of colours in the background.

The amount of abstraction that you introduce into your painting is a matter of taste and ambition, but it can be a stimulating challenge and is definitely fun. The use of mixed media adds the opportunity of introducing more variety of mark-making in the work to intrigue the eye of the viewer.

Snow Field
23 × 33cm (9 × 13in)
Acrylic paint and oil pastel
on acrylic paper

This winter painting is based on the complementary colours yellow and violet, the tonal extremes of black and white and the mid-tones in between. The scene is based on an area of open landscape that offered the inspiration of a fringe of dark trees across the open ground, with a track taking the eye into the background forming a T-shaped composition. The colour palette, enhanced by its tonal range and division within the painting, produces an abstraction which can be seen as a first step to an even more abstracted portrayal of the landscape.

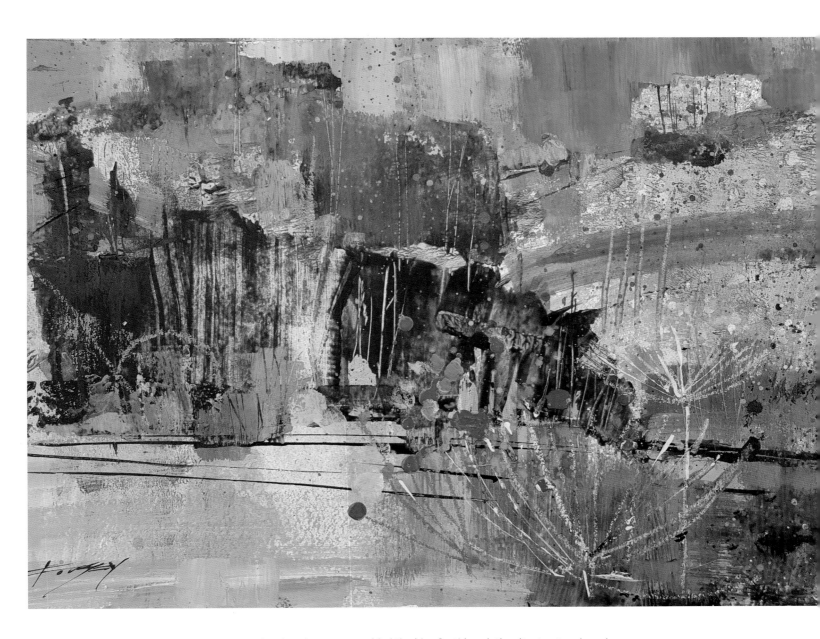

Downs Beyond

24 × 35cm (9½ × 13¾in)

Acrylic paint, ink and oil pastel
on acrylic paper

My local environment provided the idea for this painting, its structure based
on a copse in a frosty valley. The paint marks were left unaltered from the first
brushstrokes and the curving shapes suggest the field divides and hedgerow. My nod
to representation comes in the simplified frosted umbellifers in the foreground. My
colour was dabbed, dragged and splattered on the painting's surface to hint at trees
and form, and also to add a lively colour palette to the work.

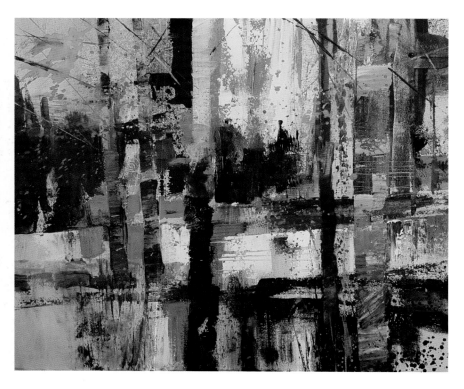

The Forest

50 × 50cm (19¾ × 19¾in)

Acrylic paint, ink and oil pastel on canvas

Here too abstraction is based on a recognizable form, in this case birch trees. I used them as the motif for this painting but wanted their form to be somewhat camouflaged by the tones and colours of both tree and background, with just a hint of a tree line discernible in the distance. The strong, upright shapes against the equally dark horizontals created an angular and structured feel to the work. The diagonal lines suggest possible tree branches but with little reference to representation. Random splatters of orange acrylic ink break up some of the angularity of the painting and hint at autumn leaves.

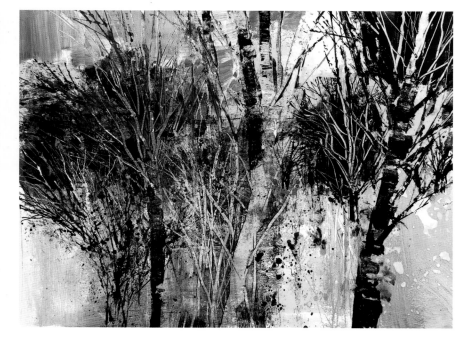

Arboretum

33 × 42cm (13 × 16½in)

Acrylic paint, ink and oil pastel on acrylic paper

I used the paint and scratch-out technique for this work, applying marks on top of the red and yellow base colour by means of a hard roller. These first marks were then overlaid with black acrylic in random shapes bearing little resemblance to reality. I explained the subject matter in the next stage, scratching negative shapes with a palette knife and painting in black uprights with the ink and roller. While they were still wet I scratched and scraped out the tangle of branches from the background shape and used ink to pull the darker marks across the sky area. Finally, I spattered violet, orange and black acrylic ink to add further interest and used just a hint of oil pastel to add a small yellow tree to the woodland.

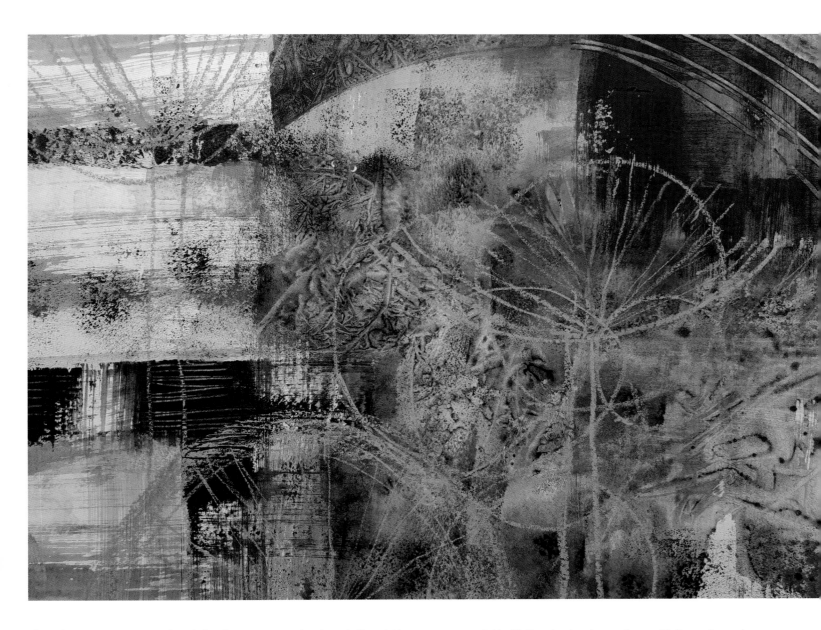

Time Piece

33 × 47cm
(13 × 18½in)
Acrylic paint and
oil pastel on
acrylic paper

Here, there is hardly a representational mark, though the faint oil pastel could represent dandelion seedheads or even bicycle wheels, spokes and tyres. The basis of the painting is a complementary/analogous group of colours – Phthalo, Indigo and Prussian Blue set against a small amount of orange. By applying the original marks with a roller and lifting out colour with a damp cloth an interesting texture has been achieved,

overlaid with the circular shapes drawn with Turquoise and Light Cobalt Blue oil pastel. The only sense of depth and scale is given by the large size of the semi-circular motif at the front with smaller shapes behind it. I consider this a completely abstract work with little sense of reality; the viewer is left to decide what the shapes and colours are saying to them.

Index